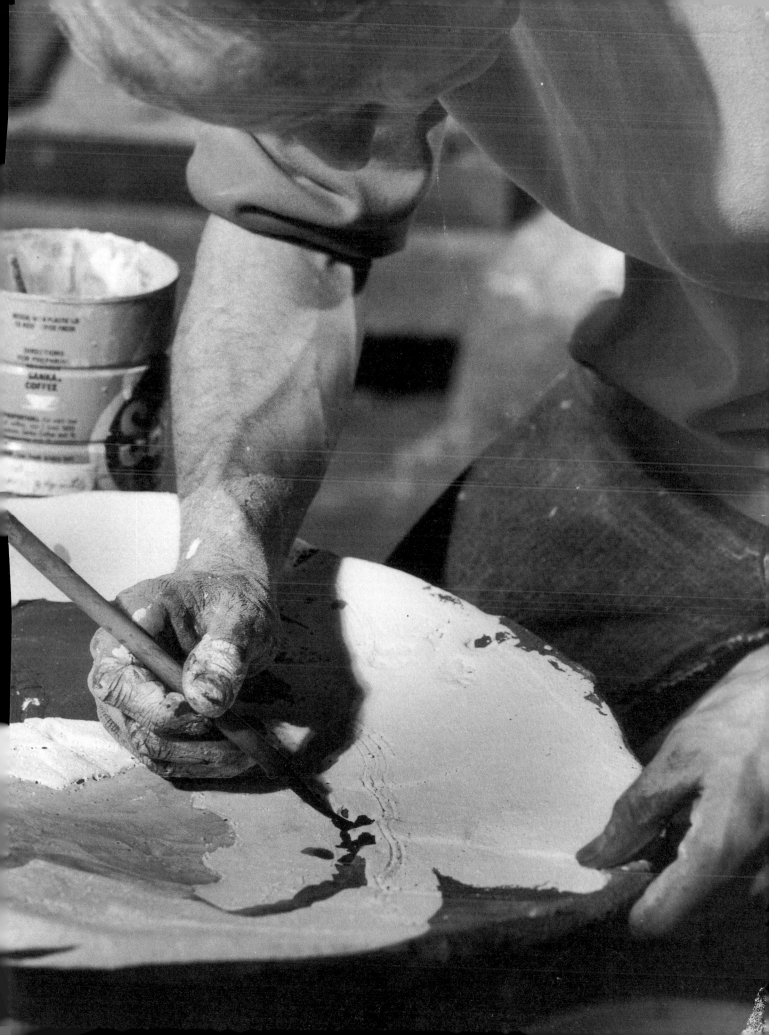

Paul Soldner: A

Contents

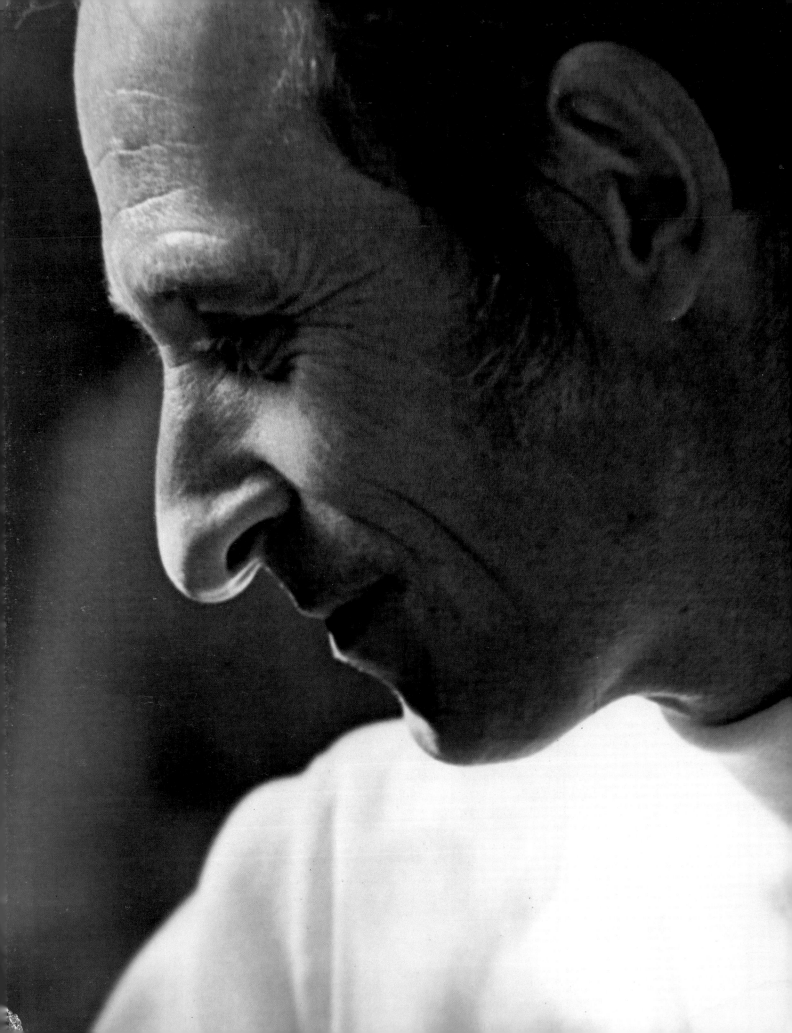

President's Foreword

SCRIPPS COLLEGE HAS LONG BEEN KNOWN FOR ITS EXCELLENCE IN THE visual arts. The founders of the art department—Jean Ames, William Manker, Morgan Padelford, Millard Sheets, and Albert Stewart—were remarkable for their accomplishments as artists and as teachers. Balancing their own creative work with the needs of their students, they provided instruction while serving as models for living life as an artist. Today's art faculty continue the distinguished tradition of the artist-teacher, and Scripps' reputation in the arts remains as vibrant as ever.

Institutional reputation is the collective reflection of individual effort. It is with a mixture of pride, gratitude, and regret that we honor an individual on our faculty, Paul Soldner—pride in his accomplishments, gratitude for his contributions, and regret that he retires this year. Paul's career at Scripps has epitomized the blending of individual creative effort with a devotion to teaching that is central to the department's tradition, and his influence has extended well beyond the classroom. The success of the Ceramic Annual exhibitions, now in their forty-eighth year, is rightly attributed to Paul's creative leadership. The presence of the renowned Marer Collection of Contemporary Ceramics on this campus is, likewise, a tribute to Paul—the result of his friendship with the Marers and their recognition that his presence has made Scripps College an internationally recognized center for the study of ceramics in the United States.

It is hard to imagine a career more deserving of recognition. I would like to add my thanks to those who have worked to realize this exhibition and catalogue celebrating the career of Paul Soldner. In recognizing him, we celebrate the best of art at Scripps, and we acknowledge our indebtedness to his gifts as teacher, creator, and colleague.

NANCY BEKAVAC
President, Scripps College

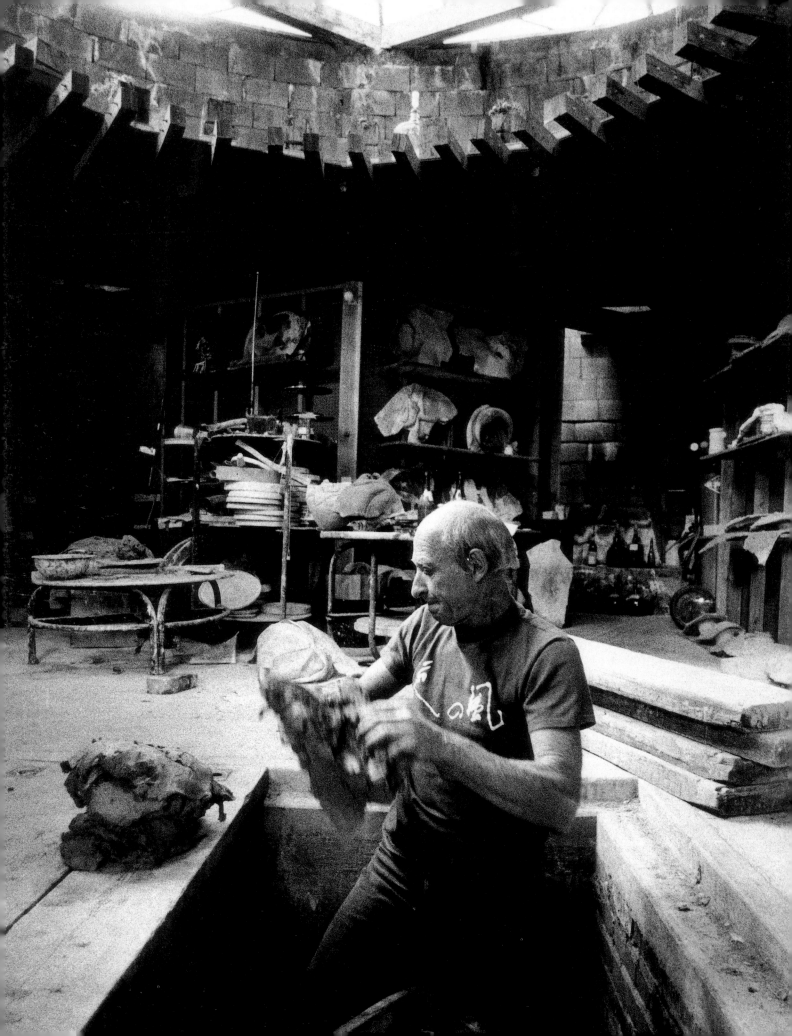

Preface and Acknowledgments

TــــــــHIS CATALOGUE, AND THE EXHIBITION IT DOCUMENTS, CELEBRATE THE
career of an extraordinary artist and teacher. It is difficult to exaggerate the
significance of Paul Soldner's role in the development of ceramic art in this
country or his importance to the arts at Scripps College. Along with Peter
Voulkos, Paul was the central figure of the ceramic revolution that began at
Otis in the 1950s and irrevocably transformed the medium. Through the
example of his own, endlessly inventive work, through the influence of his
teaching, which is legendary, and through his Ceramic Annual exhibitions in
Lang Gallery, Paul has left an indelible mark on the ceramic art and artists of
our time. His retirement this year marks the end of an era at Scripps.

The occasion of this retrospective, which we have been planning for
many years, is bittersweet. While it is gratifying to have accomplished the long-
held goal of recognizing Paul's accomplishments, it is difficult to come to terms
with the fact that he will no longer be on campus. From the Galleries'
perspective, it is equally sobering to realize that we are losing the Ceramic
Annual's chief inspiration and curator. We take solace in the sure knowledge
that Paul's work will continue to flourish and to inspire. His legacy will no
doubt prove to be as enduring as his presence at Scripps for the past thirty years
has been significant.

This exhibition and publication represent the work of a great many
individuals whose contributions we gratefully acknowledge. Financial sup-
port, without which this undertaking would not have been possible, was
provided by Scripps College through the bequest of Jean Ames, by the Fine Arts
Foundation of Scripps College, and by a grant from the National Endowment
for the Arts, a federal agency. For letters in support of our grant application, we
would like to thank Martha Drexler Lynn, Vicki Halper, Jay Lacoutre, and
Gerry Williams. Fred and Estelle Marer, Garth Clark, Louis Newman, and
Frances Kelly all provided invaluable assistance in securing loans. Lenders to
the exhibition are listed below, and we applaud their generosity. The exhibition's
two-year tour has been masterfully organized by David Smith of Smith Kramer

Soldner lifting clay out of clay pit in his
Aspen studio, 1970

9

Fine Arts Services. For their excellent essays in this catalogue, we would like to thank our authors Elaine Levin, Mac McClain, and Mary Davis MacNaughton. Mary's essay on Paul's teaching is based on interviews graciously granted by a number of his former students: Bennett Bean, Beth Changstrom, Phil Cornelius, Kris Cox, Rick Dillingham, Sjoran Fitzpatrick, Richard Gerrish, Norm Hines, Jun Kaneko, Sana Krusoe, Beverly Magennis, Donna Nicholas, Joe Soldate, and Linda Rosenus Walsh. Elizabeth Villa helped prepare the bibliography. The catalogue, produced by Perpetua Press, was carefully edited and designed with great sensitivity by Tish O'Connor and Dana Levy, respectively.

The real work of bringing this complex project to fruition has fallen to Mary Davis MacNaughton, Curator of Exhibitions and Assistant Professor of Art, Scripps College. One could not hope for a better curator. Mary has overseen every aspect of the exhibition and catalogue, from conception to realization, and has done so with a thoroughness, sensitivity, and professionalism that are entirely characteristic. She has been supported by the Galleries' staff, whose efforts we acknowledge with particular gratitude: Steve Comba, Registrar; Kirk Delman, Exhibitions Assistant; Gary Keith, Galleries Manager; Kay Koeninger, Curator of Collections; and Barbara Senn, Administrative Assistant.

Neither this exhibition nor this catalogue could have come into being without the support and encouragement of Paul and Ginny Soldner. They have extended their famous hospitality to our authors, devoted hours to interviews, and participated in every aspect of the project, from helping to select work for the exhibition to producing family photographs for the catalogue. Like the generations of students who have worked with Paul, those of us who have played a part in this enterprise have witnessed his creativity, enjoyed his quiet support, and marveled at his unfailingly generous spirit. And, like those students, we know that we are privileged.

MARJORIE L. HARTH, Director
Galleries of the Claremont Colleges
Montgomery Gallery, Pomona College
Lang Gallery, Scripps College

Lenders to the Exhibition

American Craft Museum, New York, N.Y.
Arkansas Art Center Foundation Collection, Little Rock, Ar.
The Art Works, Riverside, Ca.
David and Pamela Banks, Pasadena, Ca.
Tom Benton, Aspen, Co.
Bernard and Joan Bloom, Boulder, Co.
Aldo and Judy Casanova, Claremont, Ca.
Mr. and Mrs. Truman Chaffin, Los Angeles, Ca.
Robert and Pat Chapman, Mt. Baldy, Ca.
The Chubb Corporation, Newark, N.J.
Contemporary Crafts Association, Portland, Or.
Marcia Cowee, Aspen, Co.
Jennifer Coile, Los Angeles, Ca.
Charles and Beverly Diamond, Newport Beach, Ca.
Everson Museum of Art, Syracuse, N.Y.
Charlene Felos, Huntington Beach, Ca.
Mr. and Mrs. Glen Hampton, Pasadena, Ca.
High Museum of Art, Atlanta, Ga.
Nikki Joy Jackson, Claremont, Ca.
Mike and Connie Layne, Claremont, Ca.
Doug Lawrie, Atascadero, Ca.
Pamela Leeds, Los Angeles
Lee and Joanne Lyon, Aspen, Co.
Sam and Alfreda Maloof, Alta Loma, Ca.
Fred and Estelle Marer, Los Angeles, Ca.
Gerald and Lynn Myers, Pasadena, Ca.
Dr. and Mrs. Malcolm Nanes, N. Y.
Louis Newman Galleries, Beverly Hills, Ca.
David M. Philips, Riverside, Ca.
Private Collection, Altadena, Ca.
Private Collection, Aspen, Co.
Prudential Insurance Company of America, Newark, N.J.
Sangre de Christo Arts and Conference Center, Pueblo, Co.
Scripps College, Claremont, Ca.
Mr. and Mrs. Christopher D. Sickels, La Jolla, Ca.
Mr. and Mrs. Samuel Skolnik, Los Angeles, Ca.
Howard and Gwen Laurie Smits, Montecito, Ca.
Ginny Soldner, Aspen, Co.
Garrett Sullivan and Stephanie Soldner Sullivan, Denver, Co.
Lynne Wagner, Sayville, N.Y.
O. Louis Wille, Aspen, Co.

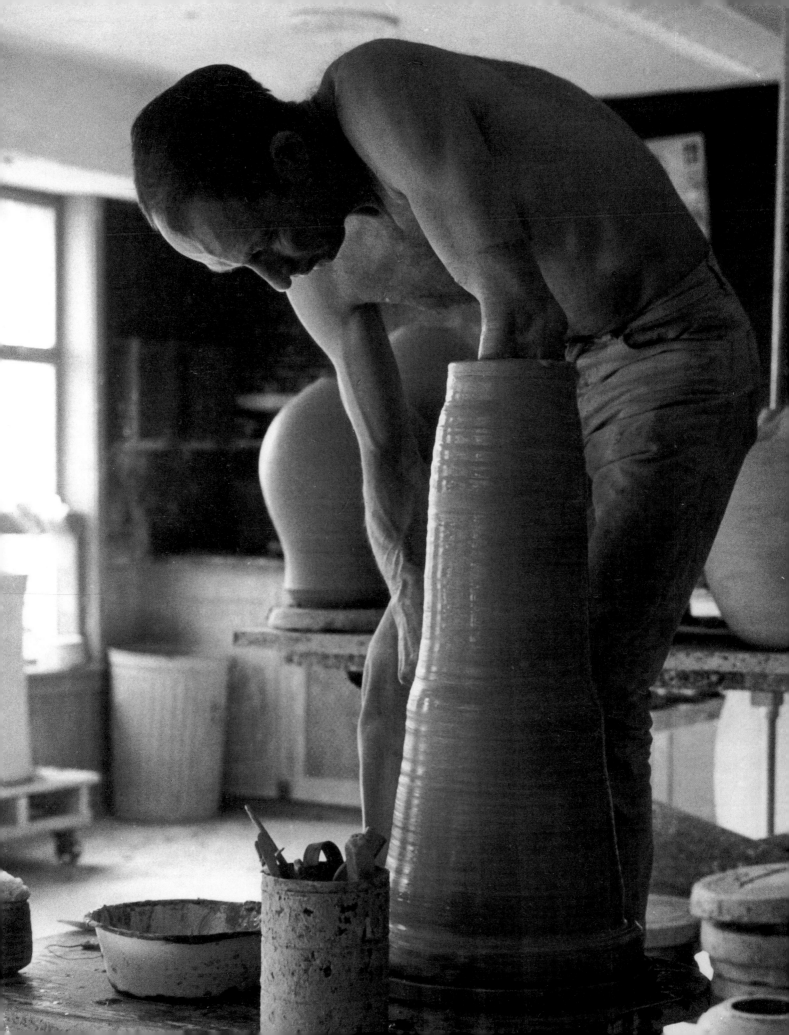

Soldner: A Life in Art

by Elaine Levin

A CERAMICS TEACHER IN GENEVA, SWITZERLAND, HEARING PAUL
Soldner advise his students to take chances in their work and risk failure, later
told him, "You are a very dangerous person."[1]

Perhaps Soldner's advice was the creative equivalent of inciting the
group to riot. But to his many generations of students at Scripps College and at
workshops around the world, he has been not an artistic anarchist but an
inspirational teacher and innovative artist. Indeed, because of his unique contri-
butions to American ceramics, Soldner stands shoulder to shoulder with the
foremost contemporary ceramists Robert Arneson, John Mason, and Peter Voulkos.

Peter Voulkos, who was on the threshold of making clay an expressive
art medium, opened the door to contemporary art for Soldner. Soldner was the
first student admitted to the department that Voulkos had established in 1954
at the Los Angeles County Art Institute (now Otis Art Institute/Parsons
School of Design). In this inspiring program, Soldner learned to follow his own
instincts about the possibilities for clay. This self-confidence, combined with
his inventive mind, prepared Soldner for making discoveries that would change
the course of contemporary American ceramics. Soldner introduced Ameri-
can-style raku, a low-fire process, and, in so doing, helped to legitimize low-fired
ware. Through his explorations of this technique, he has expanded the
aesthetic possibilities for clay.

Before embracing clay as his primary medium, Soldner had shown a
singular aptitude for solving mechanical problems. In some forms of art, the
mechanics are relatively simple, but with clay technical progress allows new
aesthetic possibilities to be explored. Soldner has devised many significant
improvements in the equipment essential to working with clay—mixers,
electric wheels, various types of kilns, and flexible shelving. He was one of the
first ceramists to understand technical constraints, devise and build solutions
to these problems, and then teach them to others.

Soldner has been in the forefront of those artists working to create a new
place for the vessel in contemporary ceramics. In the early 1950s Voulkos

Soldner using extended throwing
technique, Scripps College, 1958

13

questioned the vessel's relationship to function, an issue debated by ceramists ever since. Beginning in the 1960s the vessel fell into disfavor with many artists who contended that only ideas expressed in sculpture would bring work in clay recognition from the larger world of art. All ceramists had to acknowledge this debate, but many disagreed with its premise. Not only did Soldner not abandon the vessel, he accentuated its character through special attention to the parts that make up the whole: the rim, foot, neck, and surface embellishment. Along with Toshiko Takaezu, Wayne Higby, Michael Frimkess, Betty Woodman, and other ceramists, he kept vessel-oriented ware from falling to stagnation and disregard.

Education

Soldner's strength of purpose did not come easily. His interest in art, born in elementary school in Ohio, almost died there when his eighth-grade teacher ridiculed his watercolor painting of a sunset, calling it a picture of a fried egg. Intimidated, Soldner avoided formal art classes in high school. In college, where he majored in pre-med and minored in art, he discovered photography. The camera produced realistic images that people accepted.

At Bluffton College Soldner also discovered clay. Intrigued, and showing less trepidation than in his high school days, he constructed a potter's wheel, using directions from an article in *Popular Mechanics* and parts from a Model A Ford. Although he could find no one who could tell him how to use the wheel, undaunted, he began using the homemade wheel like a woodworker's lathe, turning the outside form, then carving to hollow out the interior. Several years later, he saw Charles Lakofsky demonstrate throwing on the potter's wheel and realized that the plasticity of clay made pulling up a wet form possible. World War II cut short Soldner's explorations in clay. In 1942, while a senior, he was drafted into the Army. As a Mennonite, he was a conscientious objector, which gave him IAO status. He was assigned to a noncombat medical detachment and, as the detachment's first sergeant, saw action in Belgium, Germany, and Austria.

After the war Soldner returned to Bluffton College to finish his B.A. Although he had performed well as a medic, the experience convinced him to shift his major to art. After graduation he taught art in northern Ohio, traveling to different schools to initiate art programs. Soldner gradually recognized the limitations of his art skills. He recalled thinking, "There's much more to art than what I've been taught."[2] Deciding he needed an M.A. in art education, he chose a school in the West, partly for cooler summers and partly for the opportunity to see more of the country.

Soldner could not have foreseen where this serendipitous decision would lead him. The GI Bill financed the four summers (1950–1954) he spent at the University of Colorado, Boulder, working in the fine arts. During his third summer there, he took a ceramics class with Katie Horsman, a talented and inspirational teacher from Scotland. This experience was Soldner's epiphany; the second was to fall in love, along with his wife Ginny, with Colorado's scenic beauty to which they kept returning. In 1955, after exploring many parts of the state, "Aspen," Soldner recalls, "found us."[3] They purchased a sage-covered field on the outskirts of town and camped on it every summer for ten years, slowly working to establish a permanent home.

Horsman's ceramics classes changed Soldner's mind about continuing in art education. He now envisioned becoming a rural studio potter, the kind of humble artist written about in the few ceramics magazines available at the time. Since such a career change required a specialized skills degree, he

discussed this next step with potters Nan and Jim McKinnell, two of the most knowledgeable senior members of the Colorado ceramic community. Their suggestions and his own research led him to Peter Voulkos, a potter who was winning awards in national exhibits. Voulkos had just been invited to establish a ceramics department, including an M.F.A. program, at the Los Angeles County Art Institute. Soldner, Ginny, and their young daughter packed their belongings into a used Plymouth station wagon, added a trailer, and drove west. Enrollment in the new program thrust Soldner into one of the most significant chapters in the history of American ceramics.

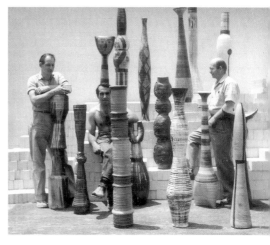

Left to right: Paul Soldner, Peter Voulkos, and John Mason at Los Angeles Country Art Institute, 1956.

The Los Angeles Art Institute

Much has been written about the highly charged atmosphere Peter Voulkos created at the Institute. As a young potter with a fine arts background, Voulkos had already earned a reputation for exceptionally competent throwing, for innovative surface designs, and for producing large-scale functional ware. But he had no experience as a teacher in an art school, let alone as chairman of a ceramics department.

For several weeks in the fall of 1954 Soldner was the only student enrolled in the program; Voulkos treated him as his equal. Since the department had no equipment, the first assignment was to find or build the fixtures they needed. At the time, kick wheels were heavy, high, and massive. Soldner's new wheel, using the strength of a truss design of a wheelchair, was lighter, lower, and less cumbersome. Characteristically, he applied a concept from one context to a situation far removed from the original. (Perhaps he recalled the time when, again consulting *Popular Mechanics*, he had built a small electric kiln using toaster elements for wiring.) Voulkos rewarded Soldner's ingenuity by placing an order for eight kick wheels. Other ceramics instructors, including Laura Andreson at UCLA, soon ordered the Soldner wheel. Soldner Pottery Equipment, Incorporated, located in the young family's garage thus began as a part-time operation.

As the ceramics program began taking shape, Voulkos, who obviously relished functioning in the midst of a community of artists, created an ambiance that permitted—indeed, encouraged—innovation and experimentation. In those early years, Voulkos taught by example; since he did not have a separate studio, the classroom became his workroom. He maintained a noncritical approach, encouraging independence and accepting new ideas. In the postwar period, non-Western concepts exerted a strong influence on the arts on the West Coast, freeing the artist from conventional ideas and methods. Voulkos began to see the vessel, his primary form, as an entity beyond traditional function. He attached slabs cut into abstract forms to the surface of a pot whose wheel-thrown parts he intuitively assembled. Sometimes he hit the form with a wooden paddle to create texture and to undermine symmetry.

Word of Voulkos's unorthodox use of clay attracted students from other ceramics programs and professional artists from a variety of disciplines. Voulkos promised that there would be "no rules, no absolutes," a philosophy that brought together John Mason, Ken Price, Malcolm McClain, Billy Al Bengston, and others, a disparate group united for all-night sessions with clay. Soon the basement ceramics department throbbed with the hum of wheels, the sounds of clay being slapped and pounded. A "night person" in his work habits, Voulkos kept the classroom open twenty-four hours a day. Although the late-night sessions interfered with family life, Soldner remembers that "you hated to leave because you were afraid you'd miss something." [4] Voulkos's teaching was not necessarily confined to the classroom—he considered the whole city

an educational experience. Students, teacher, and anyone who wanted to join the caravan traveled to exhibits and museums, to see new architecture, or even to check out a new jazz band. Back in the basement, Mason and McClain squared off wheel-thrown or hand-built forms to which they added thrown and paddled feet and necks. Although Soldner was part of this group that subscribed, loosely, to Zen philosophy, he resisted applying Zen principles to his work. Unlike other students, he was not yet prepared to make asymmetrical pots or to "look at pottery in terms of the unexpected, the accidental, and the spontaneous."[5]

Instead, Soldner produced wheel-thrown vases decorated with brush strokes or slabs of clay applied to the surface. He also worked on pieces taller than the one- and two-foot-high vessels typical of that time. (Mason and Voulkos did not begin to work on large-scale pieces until after Soldner had left the Institute.) Soldner's inventively shaped four- to six-foot-tall floor pots were thrown in one piece: to pull the form higher and higher, he added a "doughnut" of clay to the rim as needed to continue developing the piece. As the pots grew taller and closer to human height, he devised a special foot control in order to run the wheel's motor while standing on a stool.

Looking back on working with Voulkos during this time, Soldner attributes his hesitancy to be more experimental to his Midwestern conservatism. Soldner was thirty-three when he arrived in Los Angeles, a few years older than Voulkos and more mature than the Institute's young students. Soldner worked successfully to find his own direction, not just mimic Voulkos's aesthetic. His floor pots were so unconventional that in 1957 the director of the Lowe Gallery in Coral Gables, Florida, refused to accept a Soldner pot for the Gallery collection, even though in their own competition it had been awarded the "Best of Show" purchase prize for ceramics.[6] One of Soldner's pieces, however, did enter their collection, and the gallery, which is now the Lowe Art Museum, affiliated with the University of Miami, will present this exhibition during its tour. The height and the rhythmic relationship between sections of Soldner's floor pots drew the eye up and down the symmetrical column of shapes. In the mid-1950s few potters beyond the Institute used glazes so sparingly or exposed so much naked clay. The experience of working with Voulkos extended beyond the vessels Soldner made at the Institute to trusting his intuition and allowing the unknown to guide his career. The idea of becoming a simple village potter had faded from his thoughts.

Kiln Construction for the New Ceramics

The opportunity for Soldner to separate himself from Voulkos's strong influence came after his graduation in 1956. Scripps College, located at the eastern edge of Los Angeles County in Claremont, asked him to substitute for the ceramics instructor Richard Petterson, who was taking a leave of absence. Soon after his arrival, Soldner discarded the school's old, small kiln and the inadequate and cumbersome potter's wheels. The low, more powerful electric wheels he designed enabled students to produce large objects. Together with his students, he built a larger kiln—the first of many he would construct at Scripps—and removed a classroom wall to expand the ceramics lab. When the department needed machinery to mix large batches of clay, Soldner bought and modified a used marshmallow mixer. Since Petterson remained abroad for three years instead of returning after one, Soldner continued to improve the facilities. With student help, he built a gas-fired, round, bottle kiln with a seven-foot interior diameter. Inspired by a visit to a rural Southern potter, Soldner led his classes in constructing a groundhog-style kiln, a long, low, and narrow kiln that

can be entered only by crouching. Each project provided the students with a kiln-building experience unique to Scripps.

In 1963 Soldner accepted an invitation from the Peace Corps to teach its volunteers to build high-fire kilns. They would, in turn, be teaching potters in Columbia, Peru, and Puerto Rico to produce high-fired ware instead of their traditional, but breakable and uneconomical, earthenware. Soldner's few weeks in Puerto Rico tested his ingenuity for using available materials. He discovered that firebricks, used as ballast in the holds of empty ships, were discarded when the ships were reloaded. Those bricks, and the availability of kerosene, made the kiln-building project possible.[7] Back at Scripps, Soldner used that experience to add a parabolic arch kiln with an eight-foot high interior and a dual-chambered catenary-arch salt kiln to the school's facilities. His experiences at the Institute and in Puerto Rico continued to develop his flexibility in problem-solving. Living in Aspen part of the year also encouraged creativity in kiln-building. Limited quantities of the usual energy sources—gas and electricity—led Soldner to consider oil as an alternative fuel. The difficulty with using oil is that it must be converted to a vapor before it will burn properly.[8] Exploring the possibilities with his customary thoroughness and concern, Soldner solved the problem by 1965, pioneering the use of oil to fire all types of kilns.[9]

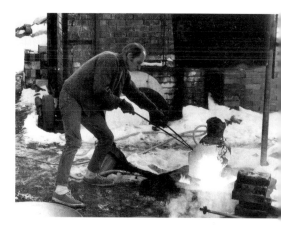

Soldner pulling pot from red-hot raku kiln for post-fire smoking and cooling ware in snow, 1966

Appropriately, the American Crafts Council asked Soldner to write a booklet on kiln-building, a subject of increasing interest to ceramics students and teachers nationwide, but one rarely documented. *Kilns and Their Construction* (1965) covered concepts as well as technical details and explained why he preferred the catenary shape.[10] On a visit to Australia in 1970 Soldner was surprised to be greeted by potters with this booklet in hand. (Curiously, they erroneously attributed the invention of the catenary arch to him.)

During the 1970s environmental problems, especially in urban areas, became an issue. Government agencies, including the Occupational Safety and Health Administration (OSHA), placed restrictions on emissions from salt and reduction firings and on the use of gas. Soldner addressed these problems in a 1974 article for *Studio Potter* magazine, in which he suggested exploring nuclear and solar energy as substitutes. Around the same time, at an American Crafts Council conference in Fort Collins, Colorado, he experimented with solar heat as an alternative energy source for kiln-firing. Interested spectators helped by holding mirrors to focus the sunlight onto a cardboard box until the sun's energy ignited it. The experiment succeeded in directing attention to the search for nontraditional solutions.

Raku in California

The circumstances that led to Soldner's first experiments with raku have become part of the folklore of American ceramics. Raku is a low-fire, fast-fire process first employed in sixteenth-century Japan to produce special wares for the tea ceremony. Although the event that precipitated Soldner's innovations was a fortuitous accident, he was prepared by past experience to go beyond the superficial toward deeper explorations, beyond technique to concepts and underlying philosophy.

Soldner was not the first American to experiment with raku. In the 1940s other Americans—Warren Gilbertson in Chicago, Carlton Ball at Mills College in Oakland, Jean Griffith in Seattle, and Hal Riegger in northern California—worked with the process. Gilbertson retained the form and content of Japanese tea ceremony vessels, whereas Griffith tried smoking pots, and Riegger explored primitive firing methods. It remained for Soldner to see the

17

fresh potential in raku, however, and to fire the imagination of ceramists nationally and internationally.

The genesis of Soldner's raku occurred at the 1960 Lively Arts Festival in Claremont. Faculty and students from Scripps College regularly participated in this annual fair by giving special demonstrations. In previous years, throwing on the potter's wheel had been the ceramics department's primary contribution. Preparing for the 1960 fair, Soldner searched through Bernard Leach's *A Potter's Book* (1940) for something new and different to show the public. Leach described a garden party in Japan during which the guests decorated bisque ware and then fired it within an hour in a small kiln.[11] The process was an updated version of a sixteenth-century technique used in Japan specifically for making tea ceremony wares. Soldner was not familiar with the Japanese tea ceremony, its utensils, or tea bowls, but firing ware quickly seemed ideal for the fair. Soldner was also personally interested in the technique since he was thinking about the possibilities of low-fired ceramics.

Leach did not provide many technical details, but Soldner had no difficulty building a small, portable gas kiln. At the festival, Soldner entranced visitors as he gingerly removed the first glowing pot from the kiln's red-hot interior and plunged it, sizzling and spitting, into a nearby fish pond. In his book, Leach had described cooling pots by air, but Soldner hoped water would dramatically hasten the process. It did, but the results were disappointing: the pots cracked and failed to produce the subtle colors Leach had praised. Late in the day, on an impulse Soldner rolled a few hot pots in a nearby pile of pepper tree leaves. The garish colors he was anxious to subdue were tempered by the smoking leaves, which left hints of a subtle pattern. This intuitive act distinguished American raku from its Japanese heritage. Unaware that he was making history, Soldner returned to Scripps that night, determined to improve the technique. He made a new clay body with a higher percentage of sand, then dried, bisqued, and glazed the pots for the next day's firing, which produced more encouraging results.

Raku ware differed radically from most ceramics produced in the late 1950s and early 1960s. The American public was most comfortable with the sophisticated styles derived from European ceramics. High-fired stoneware was the medium of choice for Voulkos and those who followed his lead toward large-scale, assembled sculptures. To withstand a raku-firing, the clay had to be more resistant to temperature fluctuations than stoneware, but at the same time it was softer and more fragile. The resulting vessels were relatively small, since each piece was removed from the red-hot kiln with tongs. Raku, however, did suit the expressive use of clay that was part of the times; indeed, because the potter had more control over the fire and was able to judge the atmosphere in the kiln, each piece could be fired differently. Raku necessitated a close relationship between vessel and potter,[12] and capitalizing on unexpected results demanded flexibility. Soldner's exposure to Asian art and the Zen idea of "going with the flow" now made sense. He was prepared to accept conditions he could not completely control.[13]

Elements of the process continually evolved as Soldner tried different post-firing materials—sawdust, newspaper, straw, rope—some of which left interesting imprints. Quickly cooling a thickly applied glaze produced a wild crazing. Placing the pot in a container filled with sawdust allowed the smoke to penetrate, making the crackled lines highly visible. Applying a white slip on a pot and smoking it under different conditions changed the color to jet black.

For about three years Soldner's experiments with this low-fire process remained secondary to his production of high-fired stoneware floor pots. Yet

the fact that some of the finest historical pottery—Egyptian, Greek, pre-Colombian, and Native American—was low-fire and of relatively modest size encouraged him to continue experimenting. A serendipitous encounter in the late 1950s with Kirasawa Kanishiga, a Living National Treasure (an honor awarded distinguished artists by the Japanese government), had given him added insight. Kanishiga used clay in an expressive, spontaneous manner, throwing ware that shunned symmetry. His respect for the organic qualities of clay profoundly influenced Soldner. Because most Americans were not prepared to accept what appeared to be an imperfect pot, it required courage for Soldner to submit raku-inspired work to the 1964 National Ceramic Exhibition at the Everson Museum in Syracuse. To Soldner's surprise, this showcase of American ceramics accepted all three of his vessels and awarded one a first prize. In a world focused on stoneware, the honor and recognition of this award gave Soldner's new work the legitimacy it needed.

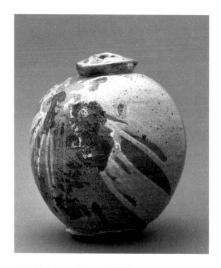

Paul Soldner, *Vase*, 1966, stoneware, Seattle Art Museum, Gift of Anne Gould Hauberg (not in exhibition)

His work with the raku process permanently altered Soldner's concept of form. No longer concerned about western principles of classic vessel proportions, he gently modified wheel-thrown shapes by paddling and by adding an inverted saucer or "doughnut" of clay as a neck. He was applying to this smaller-scale ware a technique he had used on his floor pots. But instead of shaping the neck further on the wheel as he had done earlier, he allowed it to remain fluid (see illustration, right). This produced an asymmetrical body and foot and emphasized the organic character of clay.

Soldner did not find traditional glazes, which he had essentially discarded earlier, appropriate for this new ware. Instead, he brushed on stains and oxides that interacted with gestural, incised lines and patterns produced when the pot was placed in a post-firing container for smoking. The process and the results were in keeping with the abstract expressionist aesthetic that continued in Soldner's work. Accidental effects and a spontaneous approach to decoration were encouraged by the process, but it also permitted Soldner new areas for control. The post-firing smoking required only covering the object with a container such as an oil drum. A single sheet of newspaper inside the drum, inflamed by the vessel's heat, was enough to blacken the pot completely. By lifting the rim of the container, Soldner could regulate the amount of air he wanted to reoxidize the vessel.

Such experimentation with form, fire, and post-firings inevitably produced some puzzling marks. In the mid-1960s Soldner was surprised to see a white halolike outline around brushed and splashed oxides and, in another case, a yellow background behind jet-black silhouettes. What caused these intriguing shadows became clear only after ten more years of experimentation. Smoking the pot after firing and then allowing a certain amount of air to reach the vessel produced this rich surface. By the late 1970s Soldner used these shadows to add depth and drama to the calligraphic, gestural lines brushed onto tall, slightly tilted bottles.

Pop Art: The Figure Beckons

In 1965, after teaching at Scripps College for almost ten years, Soldner moved to Aspen to live and work. Within a year he received invitations to teach, first at the University of Colorado, Boulder; in 1967 the University of Iowa also offered him a post. At Colorado, where he taught in the spring of 1967, the platters that had been part of his vocabulary of forms evolved into hand-built plaques. These offered a surface for imprinting and stencilling, using templates, rubber tires, or any other handy object capable of impressing a

pattern on the flat, soft clay. In Iowa, where the atmosphere of an art school prevailed, his emphasis on embellishment grew even more pronounced.

At the University of Iowa, where he taught in 1968–69, the art faculty gathered for weekly classes in life drawing, an activity that bolstered Soldner's self-assurance. Human figures now entered his work, interacting with the smoke patterns on his plaques and vessels. He later cut out photos of models from magazine advertisements, made stencils from plywood or Masonite, and pressed them into the clay. These silhouettes of running figures, animals, and profiles of women put his work, he felt, "in touch with my culture."[14] Like the legendary heroes gracing fifth- and fourth-century B.C. Greek amphoras in their time, the images of the Marlboro Man, Twiggy, and the Beatles that Soldner chose were familiar in contemporary culture in the early 1970s. When three prominent news magazines profiled black women to illustrate the "black is beautiful" movement, those images also became part of Soldner's plaques. The figures imparted a sense of movement and linked his work to art history, especially to Matisse's supple cutouts of dancers. The reintroduction of the human figure in contemporary painting was part of an aesthetic shift that began in the late 1950s. Abstract expressionism had substantially banished the figure from painting until, in opposition to that movement and in response to the materialism and affluence of the postwar period, the object and the figure reappeared. A similar pattern occurred in ceramics. Along with Michael Frimkess and Howard Kottler, Soldner reintroduced figurative expression to the vessel. Using a cartoon style of drawing filled in with china paints, Frimkess covered his vessels of the late 1960s with figures whose purpose was social and political commentary. Kottler's intentions were similar, but he used commercial decals on porcelain blanks. Soldner combined the abstract expressionist mode with familiar images that were humorous and light-hearted.

The Workshop Internationalizes Raku

During the affluent 1950s artists who had developed special techniques in ceramics were invited to demonstrate their craft at universities around the country. After receiving the National Ceramics Exhibition award in 1964, Soldner was in great demand at college departments hungry for new information. Entering the workshop circuit as this movement was in full swing, Soldner quickly realized that ordinary wheel-throwing no longer captured an audience's full attention. He soon found a simple gimmick. Hiding a long piece of rope inside a ball of clay, he would begin to throw. The foreign object destabilized the mound of clay as it turned, forcing him to fight for control and engaging the audience in his struggle until suddenly, like a snake charmer, he drew a piece of rope out of the center. As more rope continued to appear, the audience got the joke and applauded his efforts.[15]

Since then, Soldner's workshops have blended traditional throwing with the unexpected, including the destruction of a work to prove a point. He stops for anecdotal conversation, questions, and "help" from the audience to complete a piece. Over the years, Soldner has developed a slide show that momentarily superimposes two images. This nonverbal presentation, often including a photo of Soldner in his Aspen hot tub, juxtaposes his vessels with landscape, objects, and the people most influential to his work.

In the early years, by sharing information about raku with students and teachers around the country, Soldner helped alter the appearance of American ceramics. A Soldner workshop led students to understand that the possibilities were limitless, that they too could add their own ideas to this expressive direction for clay. Soldner workshop participants later adapted kilns for larger

raku ware and invented tools for handling ware of greater size; different types of kilns were constructed, and a wide variety of post-reduction materials were introduced. These experimental changes, along with multiple firings for further surface embellishment, enlarged the process, distancing American raku even farther from its Japanese origins.

Soldner's workshops, at colleges or in conjunction with conferences and symposia, have not only stretched the imagination of their audiences, but they have also taken Soldner to parts of the world he never anticipated visiting. He has given workshops in Australia, France, Wales, Switzerland, Italy, Turkey, New Zealand, Japan, and, recently, Latvia. He sometimes donates or sells the vessels he makes during a workshop to the host's collection. His works are now found throughout the world. For many of the ceramics students in these countries, Soldner is the first artist to challenge them to trust their intuition and take chances. Working on the floor, cutting, folding, and tearing a slab for a wall plaque or as a wing for a vessel, Soldner impresses found objects (e.g., a tennis shoe loaned by an audience member) into a malleable surface. Later, discussing his way of handling clay, he explains: "I like to discover what is happening with the clay. I'm more comfortable not knowing what to expect than with knowing. To allow yourself to be playful, to be at ease with the asymmetrical is difficult but necessary. Complete control," he asserts, "is in conflict with the creative act, with personal, inventive decision-making."[16]

Redefining Raku

In 1971 Soldner traveled to Japan to give a workshop. For the first time he observed raku pottery at the source and realized the differences between his concept of raku and its practice in Japan. Authentic Japanese raku is made only by a family given the title to do so. Traditional red raku tea bowls are hand-formed by pinching the clay and then bisqued in a charcoal kiln. After applying a lead-base glaze, the pots are refired very quickly in a charcoal kiln. As soon as the glaze melts, the pot is removed to cool on the ground. Black raku ware is fired at cone eight or nine, not singly but with other vessels. The black surface results from a concentration of iron and such metals as manganese.[17] When Soldner asked the potters when they smoked the pots, "they laughed and said, 'We never do. That's an American innovation.'"[18]

In the years before he went to Japan, Soldner was uncomfortable with the term "raku" as a definition for his low-fired ware. After all, he was not making tea bowls. Constantly asked to explain the meaning of the word, he had come to see it as "serendipity, a happy accident." He knew the Japanese defined raku as "comfortable" or "free," a definition that became meaningful to Soldner during his Japanese visit. He decided then that raku could be defined more broadly as "any field where skill, demonstrable skill, is finally performed so effortlessly that the performance appears to be...comfortable and rather relaxed and free."[19] In this context, raku transcends technique and a specific discipline. Yet, misconceptions linger. Soldner is frequently asked, "Are you going to raku that piece?" which he understands to mean "Are you going to smoke that piece?"[20] As a result, he avoids using "raku" as either a verb or an adjective, specifying instead exactly what process he intends to use.

In 1969 Soldner returned to Scripps with a contract to teach only during the spring semester of each year. It was an arrangement he sought in order to accommodate his many other interests—workshops, conferences, continuing construction at Aspen, and his equipment business. To maintain a high-quality program at Scripps, he chose a different teacher for each fall semester, a system that exposed his classes to a wide variety of influences and fresh challenges.

The Scripps College Ceramic Annual Exhibitions

Soldner, too, was open to new challenges. The Scripps College Ceramic Annual Exhibition, initiated by Richard Petterson in 1944, enjoyed a reputation as a ceramics forum unique in the western states. Soldner had served as exhibition curator during Petterson's absence. When Petterson returned to Scripps in 1960, he became director of Scripps College's Lang Gallery, leaving Soldner in charge of the Annual. This gave him the opportunity, in 1963, to make the Annual an all-raku event, the first exhibition ever to concentrate solely on this particular technique. Historically, the beginning of widespread interest in raku by American ceramists can be traced to this exhibition. Soldner's award for raku ware from the Everson Museum the following year gave additional impetus to the movement.

The Annual, which Petterson had organized as an open-entry exhibition, was so overwhelmed by entries that the show had become unwieldy. To alleviate this, Soldner decided to invite only twenty-five ceramists to show six objects each. The new format solved one problem, but the system for selecting eligible participants, Soldner believed, was too limiting. In 1970 he adopted the present system of choosing fourteen to eighteen different jurors from among previous Annual participants, ceramic teachers, gallery directors, studio potters, and critics. Each juror then chooses one ceramist who has not previously exhibited at Scripps and who is making a contribution to the field. As a result, uncrating each year's show becomes a process of discovery; the contents and the ultimate composition of the Annual remain a mystery until the work arrives and is assembled. Soldner attributes the Annual's remarkable longevity to this format, which gives control to a diverse group of jurors.

Soldner Pottery Equipment Expands

The Soldner Pottery Equipment Company, begun in 1955 in a Los Angeles garage, was relocated to Claremont and then, in 1964, to Colorado, where it was incorporated and grew into a full-time business. Ginny Soldner managed the administrative details, and Soldner designed new equipment or redesigned earlier models as his needs and those of his colleagues changed. He was awarded seven patents.[21] The Soldner wheel gained in horsepower, changed from alternating to direct current, and became less noisy over time (in the early years, Voulkos had dubbed it "the growler"). Soldner's own need for a clay mixer capable of handling 300 pounds led him to design and build a compact model using standard voltage.

Photography, which had once been Soldner's "bridge to art,"[22] became an adjunct to his ceramics and equipment advertising. He took photographs not only of his own work but also of objects in the Scripps exhibitions he organized. In the 1970s, after many years of selling equipment by word of mouth, the Soldners decided that increased competition necessitated magazine advertisements. Their collaboration for each monthly layout developed into a style that featured photos of Soldner wearing outlandish attire and often striking some unexpected pose with wheels, clay mixers, and folding carts. Humorous and provocative, the Soldner ad has remained a fixture in the marketing of his equipment (see illustration, left).

Each activity that Soldner has explored beyond working directly with clay has contributed to his aesthetic. Redesigning and improving ceramic studio equipment, for example, taught him to look for what he terms simple solutions, the uncomplicated, direct path toward a goal. A visit to a Georgia folk potter, Cheaver Meaders, underscored this principle. Soldner was introduced by another Georgia potter, Charles Counts. He was impressed by

Advertisement for Soldner Pottery Equipment Co., ca. 1986

Meaders's low-technology solution to practical problems—a stone mortar and pestle that worked like a millstone to grind glaze materials, and a mule-powered clay mixer. The visit had many memorable moments. Meaders, a crusty backwoodsman, greeted Soldner with, "Let me see you throw a pot and then we'll talk." Soldner obliged. Later, when a friend of Soldner's met Meaders and asked about some pots in the Georgia workshop, Meaders told him, "Some young Indian fellah from out West made 'em," a comment Soldner recognized as the folk potter's wry sense of humor. [23]

Soldner's studio, office, and living quarters in Aspen, 1965

Aspen, the Anderson Ranch, and Back to Claremont

In 1965, a year after the Soldners had taken a leave of absence from their respective teaching positions, they decided the time had come to reside in Aspen, in the domicile they had been laboriously building each summer since 1955. They moved their small manufacturing company to Colorado and incorporated. Then they worked toward full self-employment and building a professional career. Soon, eighteen-hour work days were common. Manufacturing and marketing their pottery equipment kept the wolf from the door as they invented and researched new equipment, while building kilns, making, and shipping of pots for exhibition, writing articles for publication, directing activities at a new ceramic cooperative, and constantly working toward completion of the buildings. A little time was eventually found even for skiing.

During these first years in Aspen, Soldner taught at the University of Colorado, Boulder, and later at the University of Iowa. In 1969 Scripps College contacted Soldner to ask if he would be interested in returning to their faculty as a full professor. Other institutions made similar offers. Although the offers were tempting, teaching full-time no longer fit his busy life-style. He was torn because teaching had been fulfilling and the West Coast was a comfortable place to live. Soldner missed working with students and following their development. After careful consideration, Soldner proposed an innovative plan to Scripps: he would teach the second semester and select someone with a different viewpoint to conduct his classes the first semester. To assuage the administration's concern that the program have continuity, Soldner proposed to visit Scripps at the beginning of each school year and once again, midway through, for graduate reviews. Thus, during the 1969–70 academic year, Soldner was back in Claremont. Ginny and daughter Stephanie, who was by then a high school senior, stayed in Aspen. Thereafter, Soldner split the year between Aspen and Claremont. Later, when Ginny entered the art field as a painter, they both spent six months in each place, moving a full office and other equipment twice a year. The payoff was an interesting and challenging life in both the academic and the so-called real world.

Building the Aspen compound required many skills. What Soldner knew about construction dated back to college and postgraduate years when he had helped a chemistry professor build a house and supervised the building of apartment complexes for a friend of his father. After installing the septic tank, the first project on the Aspen property was to construct a building meant to serve as a future studio. Soldner then added an A-frame unit as living quarters. Later, he converted the former manufacturing area into a living room dramatically structured around skylights and cast-cement beams. The principle that architecture should improve with age directed his designs. To that end he used rocks and wood native to the area. The Soldner compound was one of the first in the area to acknowledge environmental concerns by using the sun's energy with solar power for heating.

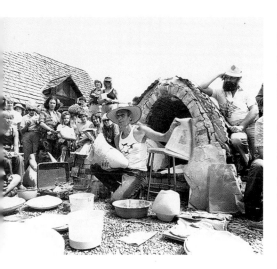

Soldner teaching a class at Anderson Ranch, Snowmass, Co., 1984

Soldner's present cone-roofed, circular studio mimics the shape of the low, sage-covered hill it hugs just beyond the main house. Besides providing space for clay, glaze materials, and ware, one area holds five-gallon bottles in which local fruits are fermenting. Wine-making, one of Soldner's many culinary interests, serves the frequent guests and visiting ceramics classes.

When the Soldners arrived in Aspen in 1955 it was a small town whose main street buildings were vestiges of its silver-mining history. During the postwar period the ski resort, expanded by several Austrians and industrialist Walter Paepcke, gradually became as well known as its summer music festival and Institute of Humanistic Studies, which is attended by top statesmen and corporate executives. By the late 1960s the nearby development of Snowmass Village needed similar cultural activities to engage its growing number of businesses and vacationers. Some land and a few ranches were made available by the Janss Corporation, a development company, and Soldner was asked to choose a ranch to develop as a ceramics cooperative. The property, which had been the Anderson Family Ranch, eventually became the Anderson Ranch Arts Center. In 1966 Soldner helped form a potters' cooperative there, then returned in 1972 to direct a ceramics program at the Center for the Hand, which shared space with a photography program called the Center for the Eye. He envisioned an intense two- to four-year work-study program in which students would earn part of their tuition. Soldner viewed the center as an opportunity to offer a professional ceramics program outside of an academic environment as an alternative to graduate school. Many students were looking for an alternative method of study in those days.

By 1975 conflicting philosophies and changes in the center's direction led Soldner to withdraw from his administrative role. Nonetheless, he continues to teach a one-week summer seminar there. Like Voulkos, who exploited the resources of Los Angeles in teaching, Soldner uses the whole area to inform his students' education: they dig clay from a local hillside and visit the Ute Indian cemetery and local grottoes. Classes in wood, photography, and other craft and art areas have also been offered as two-week seminars conducted by well-known teachers and professionals from all over the world. During the summer, the students in the ceramics classes at the Anderson Ranch are invited to the Soldner home for an evening of wine tasting surrounded by Paul's ceramics, Ginny's paintings, and pottery collected from around the world. Although he is not as involved with the daily routine at the Anderson Ranch as he once was, Soldner remains a valued consultant to the ceramics program.

Salt-Vapor Bisque

Soldner's Americanization of raku did more than give ceramics another technique. It reserved a place for low-fired ware in the American ceramic studio, but one not limited to raku. His workshops made the terms "Soldner" and "raku" synonymous, but this identity obscured other areas in his work. In 1965, while preparing work for an exhibition, Soldner had fired a vessel in a salt kiln, the only one available at that workshop site at the time. He did not think seriously about the orange flashes that resulted until five years later when, once again, he was searching for alternatives to smoked ware. Salt reacting to iron or copper in a clay body produced a surface more sensuous than one achieved through smoking. [24] Adding stains and slips (elements that were already part of Soldner's surface embellishments), then refiring and smoking produced increased depth and gave the appearance of airbrushing.

Salt-vapor bisque joined raku as another unique low-fire process. Salt-glazing had enjoyed a revival during the 1960s because of the work of Don Reitz

which inspired Betty Woodman, Ken Ferguson, and many others to explore salt-glazing. Soldner's use of salt however, was in the low- rather than the high-fire range. Reitz expanded the traditional technique by adding to the color palette. Soldner's technique and results were quite different: he placed salt directly in front of the burner's flame or on the vessel itself to produce soft blushes of pinks and oranges, alternating with colors from stains, and brushed and spattered oxides. These technical effects bloomed on Soldner's bowls, vases, and plaques from the mid-1970s through the early 1980s. His affection for Japanese brushwork is apparent in the simple strokes on one vase, which succinctly create a triad of lush cherries.

As with his explorations with raku, Soldner continually altered his approach to "salt-bisquing," as he terms it. He has shifted from using a white, porous, fragile slip to using a *terra sigillata*. This surface covering is more durable and also responsive to color. Told that he could not successfully apply *terra sigillata* with a brush and get an even surface (a warning to which Soldner reacted like a bull to a red cape), he immediately proceeded to do so. Soldner has also added black flashes to the rosy surface by burning pages from a glossy magazine to smoke his vessels.[25] In his high-necked vases of the 1980s cobalt and copper slips and calligraphic brush strokes add further color and variety. One whimsical wall piece combines the Xs and Os of tic-tac-toe with the words "luv you."

The Vessel Takes Flight

At the beginning of his professional work as a ceramist, Soldner's forms reflected traditional styles. When he began to explore raku, shapes generally labeled "bottle," "vase," or "bowl" retained only a fleeting connection with such terms. This has created a problem for Soldner and others whose work has rendered familiar terminology inadequate. At one time, Soldner used the term "voco" (vessel-oriented ceramic object) to describe his work, but the label never stuck. Undeterred, he continues to reinterpret this most fundamental of ceramic forms and has recently settled for "pedestal piece," "wall piece," or "sculpture," as appropriate labels.

In the early 1980s his slab-constructed wall pieces took flight, so to speak, and landed on his vessels. Although earlier bowls and vases had supported torn edges and flaring necks, he now applied slab-formed, winglike appendages, an addition capable of overwhelming the base. In typical Soldner fashion, he worked his way through the collapse of many pots, until the clay helped him discover a successful alignment of impressed slabs with thrown forms. An unexpected correspondence becomes apparent when these vessels are viewed in his Aspen home and studio: the winged extensions on many vessels clearly reveal a relationship to the jagged peaks of the surrounding mountains; others seem more closely related to the asymmetrical tilt of the miniature pine trees that Soldner has grown as bonsai. Soldner has absorbed the Aspen environment and created objects that are both an emotional response to and a demonstration of his affection for his surroundings.

Working to erase the boundaries between sculpture and vessels in clay, Soldner has been working recently with bronze casting, a medium particularly effective for sculpted vessels. In 1986 Soldner was invited by the sculpture department of Southern Illinois University to experiment with bronze casting. He accepted and made three bronze pieces and one in aluminum. A series of grants in 1988–90 awarded by Scripps College enabled him to experiment further with bronze casting. He contacted a foundry in Chimacum, Washington, willing to teach him more about casting techniques and to work with his

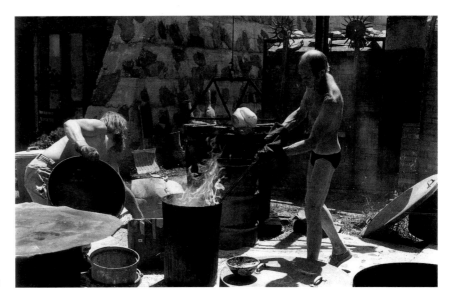

Soldner and Jim Romberg firing raku ware in Aspen studio, 1965

new ideas. His primary interest with clay was allowing the material to reveal its character. Now, as he prepares his pieces for casting, he works to have them reflect the qualities of bronze as well. This material has allowed Soldner to exaggerate and dramatize the sense of movement created by the flaring appendages moving upward from the base. The dark patina on his bronzes is related to the dark surfaces of his smoked pots, yet it is clearly characteristic of bronze casting.

For over thirty years Soldner has continually challenged himself to go beyond the conventional and to defy long-standing rules. His lean, wiry frame seems untouched by years of dealing with the weight of clay. An easy sense of humor—evident in his personal relationships, in the way he handles workshops, and even in the Soldner equipment advertisements—keeps him from taking himself too seriously. A colleague who has invited Soldner to give a number of workshops at his college over the last twenty years says he has remained "a humble man, considering his stature" in the clay community.[26] A hint of Soldner's stature and the extent of his influence through workshops, symposia, the Anderson Ranch, and his classes at Scripps College was apparent at the forty-fifth Scripps Ceramic Annual of 1989. For this celebration of the ceramics exhibition's longevity, Soldner invited thirteen of his well-known former students to show their work and asked each of them, in turn, to extend an invitation to one of their former students. In a review of the show, critic Jane Fudge noted Soldner's multiple skills as a curator, artist, and teacher. Above all, she praised his ability to instill "a sense of freedom" in his students, a spirit underscored by the show's diversity.[27]

It is most remarkable that Soldner and his art were never overwhelmed by the impact of his introduction of raku on American ceramics. In spite of his identification with this one process, his work has been anything but static. Shapes, surface embellishments, firing, and post-firing operations have constantly changed as he has worked. Salt-bisquing is still evolving in his hands, and bronze casting will predictably undergo a transformation as he explores its potential. Indeed, he continues to bring to his art a discipline and control that is open-minded, guided by intuition. The energy, curiosity, and ingenuity he has brought to a multitude of undertakings have, in subtle ways, advanced and interacted with his aesthetic development.

Soldner has consistently grasped opportunities to go beyond the familiar into the unknown. In so doing, he has provided a fruitful direction for the growth and development of contemporary American ceramics.

NOTES

I wish to express my gratitude to Ginny and Paul Soldner for giving me their full cooperation during the preparation of this material. All interviews were conducted by the author unless otherwise noted.

1. Interview in Aspen, Colorado, with Paul Soldner, July 1989.

2. "Vessels of Celebration," 41, a transcribed oral history interview with Paul Soldner, September 3–4, 1980, Department of Special Collections, University Research Library, University of California, Los Angeles, 41.

3. Aspen interview.

4. "Vessels of Celebration," 69.

5. Ibid., 87.

6. Jean Waldberg, "The Spirit of the Ceramic League of Miami," *Studio Potter Network* 3 (Spring 1990), 6.

7. Ibid., 180–182.

8. Paul Soldner, "Energy" *Studio Potter* 3 (Summer 1974), 34.

9. See Paul Soldner, "Workshop with Paul Soldner: Firing with Oil," *Craft Horizons* 28 (January 1968), 16–19, and Soldner, "Oil-Burning Kilns," *Studio Potter* 3 (Summer 1974), 49.

10. "Vessels of Celebration," 185.

11. Bernard Leach, A *Potter's Book* (London: Faber and Faber, 1945), 30.

12. "Vessels of Celebration," 135.

13. Ibid., 87.

14. Ibid., 161.

15. Aspen interview.

16. Soldner, at Santa Barbara City College, 9 March 1990, from the author's notes.

17. "Vessels of Celebration," 174-175.

18. Interview with Paul Soldner at Scripps College, April, 1977.

19. "Vessels of Celebration," 178.

20. Scripps College interview.

21. Soldner's seven patents are: 1) design for potter's wheel in Australia; 2) potter's wheel (to be disassembled); 3) electric potter's wheel with frame and table; 4) clay mixer; 5) electric potter's wheel with round design; 6) potter's wheel with V-belt drive; 7) potter's wheel with ornamental design. Soldner's distinctive trademark is also registered with the Patent and Trademark Office.

22. "Vessels of Celebration," 6.

23. Aspen interview.

24. "Vessels of Celebration," 209.

25. Aspen interview.

26. Neil Moss, chairperson, ceramics department, El Camino Community College, March 1990, notes of telephone conversation.

27. Jane Fudge, "Under the Influence," *Artweek* 20 (1 April 1988), 4.

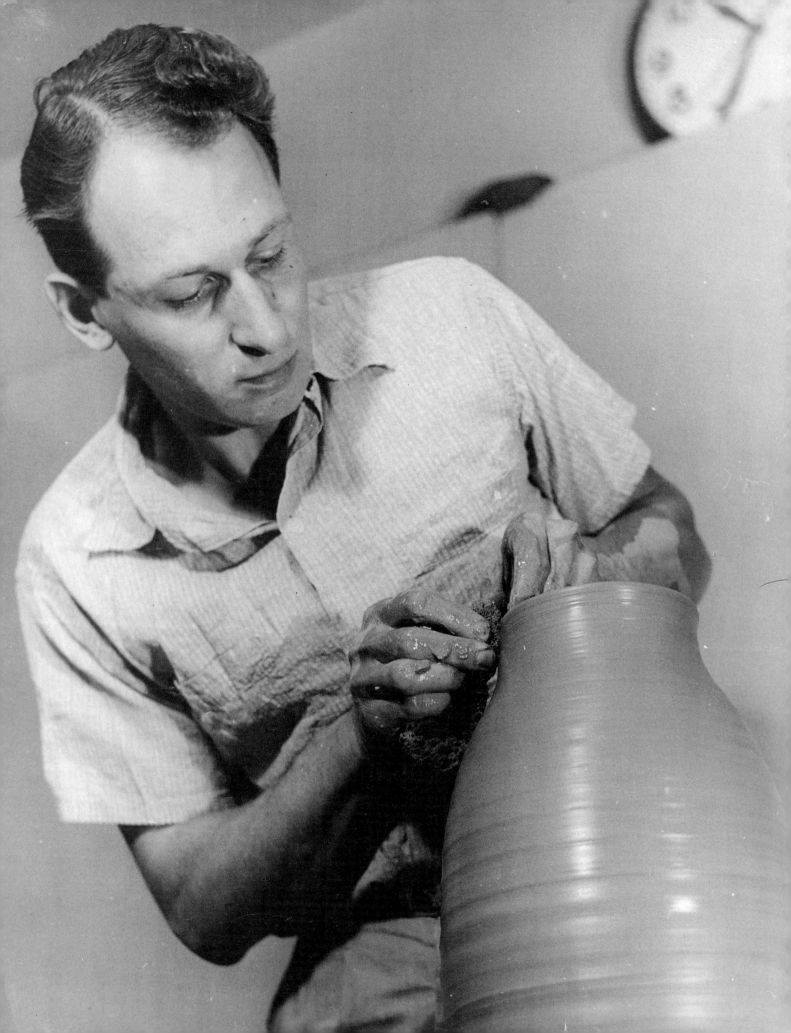

Soldner: The Student, 1954-56

by Mac McClain

F ROM 1954, ITS FIRST YEAR OF OPERATION, THE CERAMICS LAB AT THE Los Angeles County Art Institute (now Otis Art Institute/Parsons School of Design) was a twenty-four hour a day affair. When Millard Sheets, who had recently been appointed Director of the school, hired Peter Voulkos to oversee the graduate ceramics program, he agreed to several teaching conditions stipulated by Voulkos. The first was that the ceramics laboratory would be kept open around the clock for work by himself and his students. Such all-night access was unprecedented in a classroom of a Los Angeles County–controlled building, but Sheets, who had been given *carte blanche* by the County Board of Supervisors to revive and revitalize the curriculum and faculty of the Institute, had the necessary political clout to authorize it.

By 1955 Peter Voulkos was rapidly emerging as the outstanding young potter of the western United States. He had already gained wide recognition for his high-fire stoneware techniques and glazes and his fluent, highly informed decorative brushwork. Hiring Voulkos to initiate the new graduate program was considered a coup for the Institute and for Millard Sheets. That Voulkos, like so many potters and other artists of that time, was an all-night worker was a condition that could readily be accommodated.

The news of Voulkos's appointment quickly drew the attention of the Southern California ceramic world and focused the aspirations of ambitious pottery students in the region and around the country. Voulkos had been offered an ideal situation at the Institute: he could build the graduate ceramics program from scratch on his own terms. Moreover, he was given a generous budget for new equipment and supplies. In addition, he would serve as an active consultant in the planning and construction of a new ceramics building at the Institute with a firm commitment that the ground breaking would occur the following year.

Paul Soldner was the first student to enroll in Voulkos's graduate program. When the two young men sat down in the empty basement classroom of the main building to begin planning a state-of-the-art ceramics laboratory,

Soldner at the wheel, ca. 1955

their quickly established rapport set the tone for the enterprise: mutual respect, keen individuality, a total creative commitment to clay, and an eagerness to work cooperatively to make the shop the very best possible, both for the present and the future. Their experience and instinct told them that a functioning ceramics studio works best as a communal enterprise.

Although they did not articulate their mission, and they may not have fully realized the scope of their undertaking, the two potters were then embarking on a path that would transform the entire West Coast approach to pottery and the creative clay process. What they started has since been called "the Otis revolution." The timing was indeed propitious, for similar ideas were gestating in clay centers in several other regions, including the Bay Area and the Pacific Northwest.

Voulkos had been deeply radicalized by his work at the Archie Bray Foundation in Montana and by his exposure to abstract expressionism during his summer at Black Mountain College in North Carolina and his subsequent visits to New York City. The young artist suddenly began to question the traditional approach to clay with its focus on utilitarian ware. The spontaneous approach to making art that he had encountered in these places had profoundly influenced the already accomplished artist. As a teacher, Voulkos was fundamentally different from most ceramic instructors of that period. It would never have occurred to him to conduct a class by assembling his students and delivering a formal lecture or to undertake a class critique in the traditional academic manner. His instructional method was simple, direct, and, like the artist himself, down-to-earth. He taught by example, working at his art in the classroom like the students around him—wedging the clay, throwing on the potter's wheel, trimming, glazing, decorating, and firing the kiln as if he were a production potter at work in his own studio. If questions about handling clay arose, the student was invited to watch carefully his masterful techniques. His good-natured patience in demonstrations was never exhausted. His students absorbed his attitudes towards clay by osmosis.

Paul Soldner brought his own aesthetic interests and special abilities to the program. He approached ceramics with the tenacious curiosity and technical ingenuity of the proverbial Hoosier inventor. By the time the other students began to assemble for the first regular working year of the program, Soldner and Voulkos had already prowled the industrial supply firms of the Los Angeles area to find special parts to fabricate a prototype ceramic kick-wheel. The newly invented wheel, visualized and brought into being by Soldner, was, typically, low cost, made from readily available parts, and easily adaptable to the posture and body size of any potential potter. Perhaps its best feature was that it could be handily dismantled and transported in the trunk of a car.

No sooner were the kick-wheel prototypes assembled in the basement classroom at Otis and the new kiln plumbed in the parking lot outside than other students began to join Voulkos and Soldner. John Mason was the first, transferring to the Otis program from the Chouinard Art Institute a few blocks away. Then Joel Edwards came from Brooklyn. I joined the class after graduating from Pomona College, having worked as technical assistant to Richard Petterson in the undergraduate ceramics program at Scripps College in Claremont. At one point that first spring, Martha Longnecker, who later headed the ceramics program at San Diego State University, also worked in the shop.

Voulkos's pedagogical approach was both laconic and direct. When a new student enrolled in the class, Pete would greet him with, "Hi. Glad you're here. There's the clay, there's the wheel." Startled students immediately

realized that they had been given both artistic freedom and personal responsibility. They could work with clay in any way they pleased. Grades were not given, or needed, in Voulkos's classes: students measured their own progress by a keen awareness of what everyone else was doing. Ideas soon began bouncing off one another in an exhilarating atmosphere of competitiveness.

The time-honored way of learning to make pottery has always been to apprentice for a number of years under a master potter. Aspects of that relationship developed between Voulkos and his students. At least during that first year, Voulkos used the ceramics laboratory at Otis as his studio, but he never acted as a master. Treated as peers, we students worked alongside him, watching him as he went through drastic shifts in attitude towards his own work. At the same time, each concentrated on his or her own own effort. It was like sharing a studio with four or five other professional artists.

Voulkos's nonauthoritarian approach to teaching extended even to the technical functioning of the workshop. As Voulkos was preparing to leave for a summer at the Archie Bray Foundation in Montana, Paul and I gradually realized that he would no longer be around to fire the kiln. When we reminded him of this he said, "Okay, you guys come out to the kiln with me when I adjust it so you can watch what I do. You can figure it out from that." For the next three weeks thereafter, the two of us would dutifully climb out the window behind him and watch every move he made. Our observations nonetheless left us bewildered about the intricacies of a cone-10 reduction-kiln firing. Our next few firings were long, drawn-out ordeals as we struggled to move dampers and gas valves. Before we finally learned to control the rising temperatures inside the kiln by subtly shifting the top dampers, we spent endless hours debating theories of gas combustion, heat pressures, and reduction atmospheres. We learned a great deal, although in one memorable session our tinkering with the firing somehow forced the kiln's heat downward so forcefully that the asphalt of the parking lot started to melt. Maybe it was that night that we realized that the way to learn is through mistakes. We chalked it all up to Zen.

Work hours in the Otis clay studio were both flexible and all-consuming. Everyone worked whenever possible. Voulkos usually stuck his head in the window just before noon. Because the group worked together all afternoon and evening and uninterrupted into the night—processing clay, loading and unloading kilns—a strong camaraderie developed. Frequently we shared lunch, occasionally attempting to roast wieners on the flat sheet-iron hood above the flames of the kiln. More often the group drove down to Tiny Naylor's restaurant on Wilshire Boulevard for a diet lunch on the patio with Arthur Ames, Herb Jepson, or other faculty members. Ames, head of the Design Department at the school, was a genial aesthetic gadfly who never tired of teasing Voulkos about his "far-out" ware and his "barbarian" student cohorts who filled the school parking lot with kilns flaming all night long. Voulkos, who loved to joke, gave as good as he got.

On one occasion, Ames kidded Voulkos about all the Zen books lying around the classroom, joshing that the "whole shop was going Zen." The next day, labels had blossomed on every artifact in the room: "Zen" water faucets, "Zen" chairs, "Zen" clay. Humor in the Otis ceramics studio was as unremitting as the aesthetic challenge.

In the late 1950s the life of the ceramic students at Otis consisted of baseball and Zen, clay formulas and music, looking at art, going to shows, and thinking about entering the Syracuse National. Other L.A. artists often dropped by the clay lab late in the evening and the whole group would traipse across MacArthur Park to a corner restaurant we called "Big Red's" in tribute

Fred Marer, Los Angeles

to the night waitress who served with a big-city style all her own. After midnight, during the long hours of waiting for a kiln to go off or just as a short break from a work session, the group sometimes drove to the Tiffany Club on Seventh Street to hear Shelley Manne and his All Stars Band.

Before long, Voulkos and his graduate class had filled the basement room with ware stacked almost to the ceiling. The shop was bulging with raw clay and ceramic ware of all shapes and sizes, as well as ideas and stimuli. There were no barriers, no distinction between craft and art. Abstract-expressionist splashes were painted and hung along the walls, hidden from the conservative, censorious eye of the school director, Millard Sheets. The walls were covered with pictures of the sculpture of such artists as Picasso, David Smith, and Reuben Nakian. We mused and debated over the emerging tension between functional and nonfunctional pottery. Voulkos commented in an often-quoted remark, "Who wants to make another bean pot? Perfectly good ones have already been made."

Music was our accompaniment during all those hours; the record player spun all night. Voulkos preferred the sounds of the flamenco guitar, which he learned to play in a night class at Beverly Hills High School and by practicing with his usual intensity. Many of his first sculptures were given titles from flamenco songs.

Although there were no formal classroom "crits," evaluations were made constantly and communicated in subtle ways. Voulkos was teaching us tolerance and sensitivity of judgment. We joked that we could tell what he thought by the way he tilted his cigar or let it go out. But his concise comments did clarify problems. Paul Soldner recalls that Voulkos watched him unloading an overworked pot from the kiln and then said quietly, "Never decorate if it isn't needed."

The graduate students faced an even more formidable and pragmatic form of critique. Buyers, attracted by Voulkos's growing reputation as an artist, found their way to the basement workshop at Otis. By the spring of 1956, Fred Marer, who was beginning to form his definitive collection of ceramics of the period, began visiting frequently. We all knew that he had a discerning but also friendly eye; we also knew that he was dealing with a very modest personal budget. Everyone watched as he wandered purposefully through the lab, surveying the last kiln load, pausing before this pot or that. When Fred bought a pot, it was a sign of approval from a respected connoisseur; it meant encouragement and money. Everyone was living very frugally in those days.

This constant contact with the outside world was one element that made the Otis experience different. We developed a sophisticated awareness of fellow artists, sales, dealers, and galleries, as well as the emergence of West Coast abstract expressionism. We were halfway into the professional art world, no longer in the sheltered world of the school. An intense focus on a new approach to form in clay evolved from the group's interactions. This approach drastically contradicted the conventional attitudes of the ceramic world, which revered the reworking of traditional forms. Soldner recalls, "The Voulkos program went farther than the school hoped in that it encouraged the students to evolve their own direction rather than follow a set program. Sheets wanted us to be 'artisans' not artists." Our difference with Sheets was confirmed when all but one of the graduate ceramic students were excluded from the Otis student exhibition as unrepresentative of Otis. Despite this, the ever tenacious Paul Soldner vigorously pursued the degree with Voulkos and was the first M.F.A. graduate from the Los Angeles County Art Institute clay program.

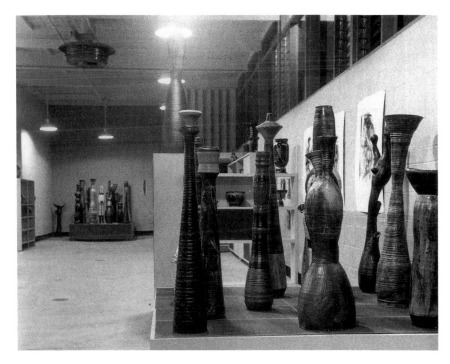

Soldner's M.F.A. exhibition, Los Angeles
Country Art Institute, 1956

Voulkos made sure that the graduate class had all the clay that it could manage. Although there were tensions, the group got along amiably for the most part, with each student working busily, self-contained and focused. Everyone was stretching to surpass individual limits and constraints. Soldner, excited by the challenge of throwing extremely tall clay cylinders, rigged up an electric wheel so that he could stand above its table top and throw clay beyond the normal size. By manipulating an extension of the foot pedal, he controlled the speed of a turning cylinder, which he had stacked so high that he declared it the tallest cylinder ever thrown—announced with his characteristic mixture of seriousness and humor.

In a recent conversation, Peter Voulkos commented to me about Soldner's role in the Otis experience, "The whole thing wouldn't have been possible without Paul. His total dedication to clay, his energy, and his philosophical humor gave him a special charisma. It's no wonder that he went on to become one of the most influential teachers and artists in the ceramics world of our time."

The students of that first year dispersed quickly and were replaced by a whole new generation of emerging artists, including Mike Frimkess, Ken Price, Jerry Rothman, Billy Al Bengston, and Henry Takemoto. John Mason left Otis, and he and Voulkos set up a private studio on Glendale Boulevard. Joel Edwards went on to be a professional potter and eventually president of the design section of the Los Angeles chapter of the American Ceramic Society. I moved to Tijuana and eventually began teaching at the Art Center in La Jolla.

A new aesthetic approach to pottery and ceramics evolved during the Otis program. The goals shifted away from the refinement of a disciplined, traditional craft and toward a prodigious vitality in the manipulation of the clay media and an impulse toward nonfunctional shape. Cylinders were squared, chopped, pounded, distorted. In that classroom the world of pottery began responding to the concepts of modern art. It was intense and it was also great fun.

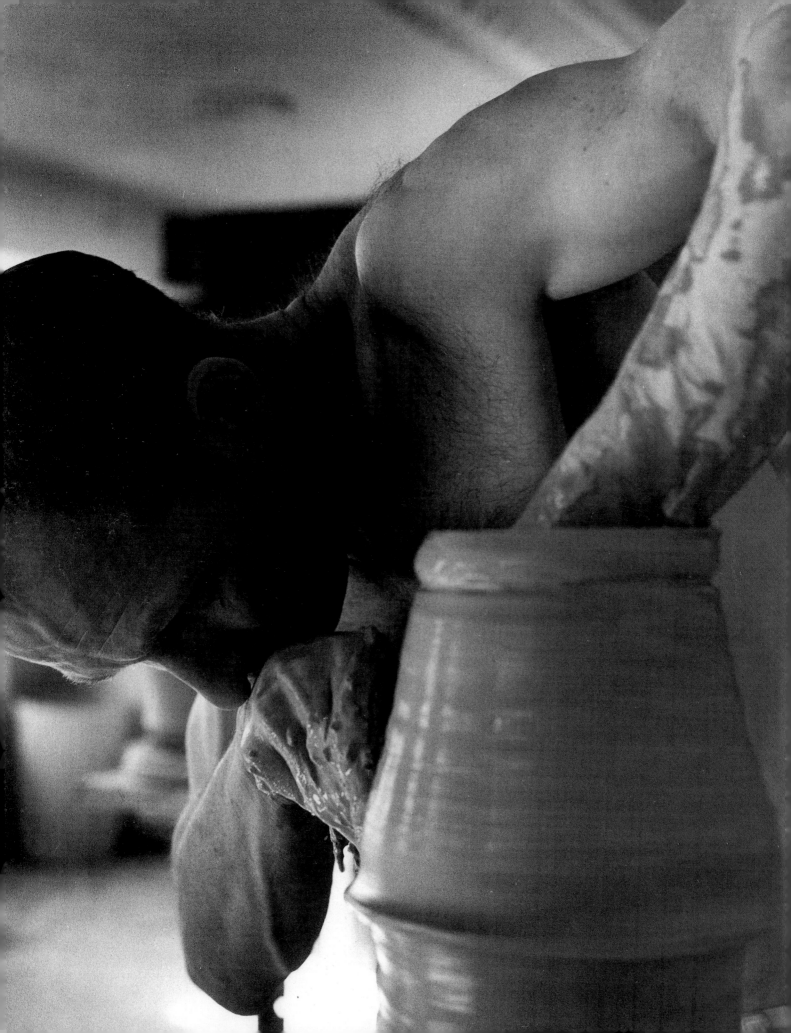

Soldner: The Teacher

by Mary Davis MacNaughton

A leader is best
when people hardly know he exists;
less good when they praise and obey him;
worse when they fear and despise him.
But of a good leader, when his aim is met,
his dream fulfilled, they will say,
"We did this ourselves."

(Lao-Tsu)

IT IS EASY TO ASSESS PAUL SOLDNER'S IMPACT ON CONTEMPORARY CERAMICS as an artist and inventor because the evidence is there: his work has been exhibited and collected from London to Kyoto; his kick and electric wheels, clay mixers, and fuel-efficient burners are used by potters from Portland to Peoria. But it is as a teacher that Soldner has had his most lasting effect on contemporary art in clay. Along with his mentor, Peter Voulkos, who has taught at the University of California, Berkeley, since 1957, Soldner helped shift the momentum of innovative ceramics from the East to West Coast during the mid-1960s. At Scripps College, where he has taught for thirty years, Soldner has created a major center of ceramic study that has provided hundreds of students—undergraduate and graduate—with a rich education. Under Soldner's direction, the Scripps program has produced an astonishing array of leading ceramists and sculptors, including Bennett Bean, Beth Changstrom, Tom Collins, Phil Cornelius, Kris Cox, Rick Dillingham, Sjoran Fitzpatrick, Richard Gerrish, Norm Hines, Sheldon Kaganoff, Jun Kaneko, Sana Krusoe, Peter Kuentzel, Ingrid Lilligren, Beverly Magennis, Kazuko Matthews, Dennis Parks, Anne Scott Plummer, Connie Ransom, Brian Ransom, Jim Romberg, Linda Rosenus Walsh, and Joe Soldate. Equally impressive is the variety of their work; all have developed distinctive styles. How did Soldner inspire so many artistic talents, and what in his teaching accounts for their individuality?

Since arriving at Scripps in 1956, Soldner has taught three types of students: undergraduates from Scripps, Pitzer, Claremont McKenna, Harvey Mudd, and Pomona Colleges; graduate students from Claremont Graduate School; and special students, who have come from France, Germany, Switzerland, and Japan as well as the United States. Soldner also has taught thousands more in the innumerable demonstrations and workshops he has given throughout the last three decades, both in this country and abroad.

In retrospect, it seems extraordinary that Soldner's one-man program has made Scripps into such a powerful ceramic center, but since 1956 he has been the magnet that has drawn young ceramists to the school. During the

Soldner throwing a tall cylinder, Scripps studio, 1960

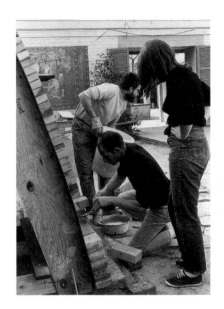

Soldner and students Dave Cohen and Janet Braley building an 8 ft.–high parabolic arch kiln, Scripps College, 1960

1960s Scripps emerged as an exciting alternative to the traditional ceramic programs at such institutions as Alfred University, which emphasized commercial ceramics over fine arts. As Bennett Bean (M.F.A. 1966) said, "When we were at Scripps, we had the feeling that this was the center of the ceramics universe and we were in it. There was a lot of energy there. We felt Scripps was the polar opposite to the aging Alfred."[1] Bean and the many students who subsequently came to Scripps found in Soldner an artist who was nationally acknowledged but personally accessible, a teacher whose ideas were definite but not doctrinaire. Soldner has always given students a broad exposure to contemporary ceramics. Since 1969 he has invited a guest teacher to Scripps for one semester each year to introduce different aesthetic approaches. He has also made students aware of diverse techniques and styles through the Scripps College Ceramic Annual, which, under his supervision for the past thirty years, has consistently presented new directions in contemporary clay with works by artists from across the country. To avoid imposing his own curatorial point of view, Soldner invites leading artists, gallery directors, and critics to select the artists to be included in the annual show. Finally, Soldner has broadened his students' perspective by teaching contemporary ceramics through discussions of work in the Marer Collection—one of the finest ensembles of contemporary American ceramics—which Soldner helped bring to Scripps.

But more than Soldner's curriculum, it has been his method that has produced outstanding artists. He teaches not by rule but by example. In this attitude, he was inspired by the three important teachers in his life: John Paul Klassen, his first art instructor at Bluffton College; Katie Horsman, his ceramics teacher at University of Colorado, Boulder; and Peter Voulkos, his mentor at the Los Angeles County Art Institute (now Otis Art Institute/Parsons School of Design). All three encouraged experimentation and worked alongside their students. Of this group, Voulkos had the greatest influence on Soldner. Voulkos converted the classroom into a studio where teacher and students worked together, an approach that was influenced by the Japanese system of apprenticeship in which a craft is learned from masters through observation and practice. "I loved the idea of learning to be a potter in Japan." Soldner, who later adopted a similar approach, commented, "The responsibility is placed on the student to learn by watching, versus the Western way of giving an assignment."[2] Soldner's preference for teaching by example may also have been shaped by the values he absorbed as a youth in his Mennonite family in Bluffton, Ohio, where he learned to emphasize deeds over words. At Scripps, Soldner based his own teaching methods on actual experience, not abstract theory. Unlike artists who demonstrate in class but do their own work elsewhere, Soldner has merged the class and the studio. As a result, students have seen his methods of hand building sculpture or throwing pots on the wheel as effective techniques, not as isolated exercises.

Another important aspect of Soldner's teaching method is to build students' self-esteem by giving them responsibility. From the beginning of their training he teaches them to mix their own clay, to make their own glaze tests, and to fire—and even to build—their own kilns. These exercises help students develop initiative. For example, when beginners ask him if he thinks a certain glaze combination will work, Soldner will often say, "I don't know; Why don't you try it and then let me know."[3] Although he knows the probable result, he understands that students learn more from their own experiments than from someone else's expertise. At the same time, he also checks students' glaze tests before they are fired to be sure they have been done correctly. This combination of freedom and guidance prepares them to be independent. As Kris Cox, who

studied with Soldner in the early 1970s, reflected, "Paul instilled confidence in me. We saw from the bottom up how kilns are constructed. We didn't learn this from a book. We got skills to construct kilns to our specific needs."[4]

In kiln building, Soldner teaches students to look for the simple structure behind complex appearances. "We constructed our own burners from pipes," Cox explained, "and never saw commercial burners until later."[5] As Linda Rosenus Walsh, who studied with Soldner in the mid-1970s, recalled, "He takes the mystery out of things. The way he teaches kiln-building, you feel safe taking burners apart, because he reduces them to their basic parts. You come out of his program unintimidated by the world."[6] Another student, Sana Krusoe, remembered Soldner's simple and pragmatic approach to firing kilns: "In firing kilns he showed us coping strategies that don't go by the book. For example, if the kiln needs more air, take out a couple of bricks. He has an open-ended, nondogmatic approach."[7]

Throughout his career, Soldner has passed on positive attitudes that enable his students to solve the problems they encounter as artists. The first problem many face is what kind of art to make. He urges them to value art of the past but to make art for the present. After encouraging students to study historical styles, he suggests they find their own. "I think that teaching the students to look," Soldner remarks, "is more important than teaching them to copy what others have done."[8] He trains them to sharpen their vision by looking closely at what is familiar and forgotten. In one class on perception and analysis in the arts, Soldner showed eighty slides he had taken of fire hydrants to demonstrate that these banal, utilitarian objects contained a whole history of technological and aesthetic change. Afterwards he asked students to create their own photographic essays, and by the end of the semester they had reevaluated bell towers, chimneys, and fences, seeing with fresh eyes things they had previously taken for granted.

Soldner pushes his students to avoid making technical ability an end in itself. He cautions them:

> Don't value too much what was so painstakingly learned. The wisdom of this was made clear to me many years ago by a drawing teacher. It happened in the last week of the semester. After complimenting me on having achieved a high level of proficiency and mastery of the drawn figure, he added, "Now, let's see what you can do with the other hand."[9]

To avoid being trapped by technical prowess, Soldner drives his students to be curious, to question past solutions, and to look for new approaches. "The most difficult thing to teach is curiosity," Soldner says. "The next is the courage to do it."[10] Having courage means taking risks, something that Soldner models in his class demonstrations. He throws pots off center or upside down, he also drops newly thrown pots on the floor to find in their crushed shapes fresh expressive possibilities.

Soldner expects graduate students to expand their ideas while at Scripps. Rick Dillingham (M.F.A. 1976), who was already a successful potter when he arrived in Claremont, found his study with Soldner to be a liberating experience. "He allowed me the freedom to grow," Dillingham recalls. "He was not a teacher who pushed or directed."[11] As Phil Cornelius (M.F.A. 1965) remembers, "Paul enabled me to go out on a limb with forms. The most important thing Paul gave me was the belief that it is okay to find your own way, that you should be different."[12] Norm Hines (M.F.A. 1963) recalls "What Soldner gave me was an attitude that said, 'Trust your instinct. Don't be afraid to experiment.'"[13]

Soldner welding a potter's wheel, 1967

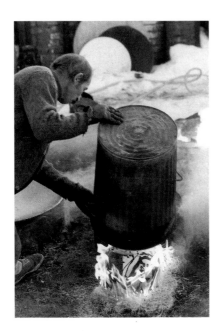

Soldner inverting can with organic material to smoke work in raku firing, Aspen, 1966

Taking risks often results in accidents, but Soldner teaches his students not to fight the unexpected but to look for the opportunities it offers. In firing raku pots the chance effects caused by the interaction of combustible materials and hot glaze during the smoking process are a source of both beauty and excitement. "In the spirit of raku," Soldner wrote in 1968, "there is a necessity to embrace the element of surprise. There can be no fear of losing what was once planned and there must be an urge to grow along with discovery of the unknown."[14] In the interest of experiment, Soldner has even been willing to sacrifice a work. For instance, he wanted to see if it was possible to draw with an oxyacetylene torch, even though he knew the thermal shock might destroy the piece. But he discovered by torching *Wall Piece*, c. 1985, that while the heat of the flame was intense enough to melt the silica in the clay to glaze, it was not high enough to break the work. By following Soldner's example of risk-taking, students learn to see the positive side of accident. "Every time I open the kiln," Beth Changstrom (M.F.A. 1966) observed, "something has gone wrong—the ware is overfired or underfired, or a kiln shelf has fallen—but Paul showed us how not to give up but to work with the unexpected."[15]

The unexpected has led Soldner to many new discoveries in his own work. In fact, he believes that "mistake, rather than necessity, was the mother of invention."[16] For instance, the much admired "halo" effect on his raku pots was the accidental result of decorating a piece with iron and copper oxide over a white slip. "After it was fired and smoked," he says, "I was surprised to find a white line had been 'drawn' around the black stain and between the smoked background. Mysteriously, it had not been done by me."[17] In addition to accepting chance occurrences, Soldner advises artists to be patient in understanding them. Enthralled by the beauty of the halo effect, he naturally sought to repeat it. After fifteen years of experimenting he realized that it occurred in the re-oxidation of the raku pot during the smoking process after its firing. Soldner also developed his technique of low-temperature salt-vapor firing by accident. He first noticed the effects of this process in the mid-1960s when he had completed an unusual firing with Dennis Parks. Soldner recalls,

> The kiln was double chambered: Dennis wanted one chamber for a salt firing, and I wanted the other for a bisque firing. I figured it would work because it would get hot enough, and the waste from the salt firing would go out the chimney. The pots were bisqued, but they didn't look right. They all had orange flashes. I made sure not to do it again. But in the late sixties, when the accident recurred, I was looking for an alternative to Raku. Then I thought, "Maybe orange can be beautiful."[18]

Soldner's acceptance of chance effects and his ability to put them to creative use reflects the influence of Zen philosophy—filtered through the Beat poets of the 1950s—which he absorbed during his student years at Otis. He encountered another form of Americanized Zen through reading the popular classic of 1974, Robert M. Pirsig's *Zen and the Art of Motorcycle Maintenance*. Soldner identified with the book's protagonist, because his own goal is to get his students to work for more than grades, just as Soldner's goal is to make his students self-motivated and creatively self-sufficient. Toward that end, he has devised a grading system that rewards hard work and initiative. For beginners, Soldner evaluates quantity not quality because, as he explains, "Quality comes out of quantity."[19] From Zen, Soldner has absorbed a nonjudgmental attitude, which he applies to creativity. He feels that grading art is inherently problematic: "I charge students with making their own image, yet I am expected to give grades based on my own taste. Art is not unlike science; we call it invention in science and creativity in art."[20] At moments when he has felt frustrated in the

creative process, Soldner has found inspiration in Zen philosophy: "The Zen way is to wipe the slate clean in order to let a new idea in."[21]

Soldner is, above all, a generous teacher, who gives to his students in many ways. Most artists keep their innovative techniques to themselves; he freely shares his. For example, Soldner has taught his low-temperature raku and salt-vapor firing processes not only to hundreds of students at Scripps but also to thousands of others at workshops and demonstrations. Like his father who moved four times to congregations in the Midwest to preach the gospel, Soldner has a missionary zeal. He has journeyed around the world to share his love of ceramics. "I don't know anyone who has done so many workshops," says Jun Kaneko. "He is a great artist—not stingy, but willing to give."[22] Soldner's generosity is also seen in his program for special students, who come to Scripps with impressive abilities but insufficient credentials for matriculation. Soldner has offered gifted ceramists a place to study, and this opportunity has inspired many to continue their education. For example, special students Richard Gerrish, Ab Jackson, Jun Kaneko, Doug Humble, Jan Massad, Tom Orr, Tim Persons, Beverly Soja, Eduardo Sanchez, and Linda Rosenus Walsh all went on to earn M.F.A. degrees. In addition, Soldner has helped students by including their work in exhibitions and supporting their applications for teaching positions.

Soldner's students have chosen different artistic careers. A few, like Beth Changstrom, Jerry Martin, Timothy Persons, and Connie Ransom, have become art dealers as well as artists. Others, like Nolan Babin, Bennett Bean, Daniela Came, Sarah Chamberlain, Kris Cox, Rick Dillingham, Goedele Vanhille Fahnestock, Noel Hudson-Reidy, Maggie Jones, Jun Kaneko, Rick Kugler, Connie Layne, Doug Lawrie, Fox Joy McGrew, Kazuko Matthews, Rodney Mott, Dennis Parks, Gayle Prunhubert, Brian Ransom, Allan Walter, Nina De Creeft Ward, Liz Williams, and Bryan Yancy, work independently as artists. But most of Soldner's students have become teachers. They are listed with their affiliations below.

Margie Allan (California State University, Chico)
Bill Brayton (Hampshire College, Amherst, Ma.)
Austin Collins (University of Notre Dame, Notre Dame, In.)
Phil Cornelius and Jan Massad (Pasadena City College)
John Fassbinder, Sjoran Fitzpatrick, and Norm Hines (Pomona College, Claremont)
Charlene Felos (Cypress College, Cypress, CA.)
S. Dennis Frandrup (College of St. Benedict, St. Joseph, Mn.)
Bill Gilbert (University of New Mexico, Albuquerque)
Cris Gonzalez (Chaffey College, Rancho Cucamonga, Ca.)
John Gordon (University of Southern California)
Ken Hendry (Colorado State University, Ft. Collins)
Jack Hopkins (California State University-San Diego)
Sheldon Kaganoff (University of California, Santa Barbara)
Merrill Krabill (Bethel College, North Newton, Ks.)
Sana Krusoe (University of Oregon, Eugene)
Peter Kuentzel (Dade County Community College, Miami)
Ingrid Lilligrin (Mount San Antonio College and California State University-Fullerton)
Berry Matthews (Pennsylvania State University, University Park, Pa.)
Donna Nicholas (Edinboro University of Pennsylvania, Edinboro)
Marge Rattle (California State University-Sonoma)
Jim Romberg (Southern Oregon State College, Ashland)
Antonette Rosato (University of Colorado, Boulder)
Adele Schonbrun (Colorado College, Colorado Springs)

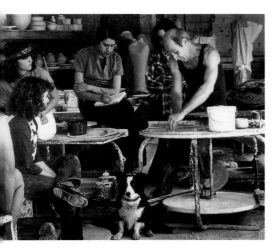

Soldner teaching glaze analysis at
Scripps College, 1970

Joe Soldate (California State University-Los Angeles)
John Stokesbury (California State University-Fullerton)
Bryan Vansell (San Francisco State University)
Ted Wiprude (Oregon State University, Corvallis)

At San Jose State University there are four former Soldner students on the faculty: Sandra Johnstone, David Middlebrook, Linda Rosenus Walsh, and Stan Welsh. Among Soldner's students who teach overseas are Jean Biagini (Art School, Aix-en-Provence), Danielle Pestalozzi Cotter (Lausanne, Switzerland), Kimpei Nakamura (Tama University of Art, Tokyo), and Setsuko Nagasawa (Geneva Art School, Switzerland).

Many of these artists still speak of the sense of community Soldner created at Scripps. Soldner gave them a feeling of family by inviting them to weekly Monday night meetings that would include potluck dinner and a varied program, often a slide presentation by a student or a session by Soldner on how to make wine or photograph ceramics. These meetings were so meaningful to students, many of whom were far from home, that some artists continued to attend long after they had graduated. What is extraordinary is that Soldner maintains contact with almost two hundred former students; each year he gathers numbers of them together at the meeting of the National Council on Education for the Ceramic Arts.

Soldner has shown his students not only how to make art but also how to live. As Beverly Magennis puts it: "He is involved in living in a creative way."[23] "Many artists have ideas about art," Jun Kaneko explains, "but what they do in actual life doesn't match. But with Paul, what he creates and how he lives all go together."[24] Most of all, Soldner exudes a sense of energy and enthusiasm for art and life that is contagious. In Bennett Bean's words: "Soldner has little 'bed warmth,' that feeling when you don't want to step out into the cold. Paul has always stepped out into the cold to do new things. He built his own house, designed his own equipment, made his own wine, and went out into the world to teach."[25]

Critics have acknowledged Soldner's impact on contemporary ceramics in terms of his popularization of raku. Roslyn Siegel wrote in the *New York Times*:

> Mr. Soldner, together with Peter Voulkos, has helped obliterate the distinction between art and craft, claiming for ceramics the same concern with pure esthetics and freedom from function that sculptors have long enjoyed in marble. Directly responsible for the introduction of the Japanese ceramic firing technique known as raku to this country, Mr. Soldner has been one of America's most influential ceramic artists.[26]

Suzanne Muchnic in the *Los Angeles Times* also noted that "Soldner's gentle insistence that clay look like clay and his introduction of Raku's iridescent, smoky effects influenced hundreds, probably thousands, of students."[27]

Soldner's students see his contribution to contemporary ceramics in broader terms. Bean believes Soldner is important because he "reinterpreted raku and Americanized the strong Japanese influence on ceramics."[28] Magennis points to Soldner's leadership in bringing "Raku and low-temperature salt-firing processes to contemporary American crafts."[29] Dillingham expands this idea, saying that "Paul was essential in getting the low-fire medium accepted as real ceramics, because before him stoneware was dominant."[30] Connie Ransom notes that Soldner's "inventions and development of ceramic equipment have revolutionized the studios of many potters throughout the world."[31] But all agree that Soldner's major contribution has been the freedom of expression that he has brought to contemporary art in clay.

Given Soldner's powerful impact on his students, one would expect their work to resemble his. This thesis was tested in 1989 at the 45th Ceramic

Annual Exhibition entitled "The Scripps Influence," in which Soldner invited thirteen former students to exhibit, each of whom then selected another artist. What was evident in the exhibition was not the similarity but the diversity of styles among those who have studied with him, an eclecticism which suggests that Soldner's influence has been less formal than philosophical. Like him, his students exhibit a love of clay and a belief in its expressive possibilities. They understand that experimentation leads to new discoveries, and have found in that process their own distinct, creative identities. Donna Nicholas recalled that "When we were at Scripps, there was never any pressure to work like him. It was understood that we were there to be ourselves."[32] Soldner is a master whose influence has been, in the words of critic Jane Fudge, "the best, most liberating kind."[33] Clearly, he has enriched the world with his multiple talents as an artist, inventor, and teacher. But ultimately, it is as a teacher, who has inspired a younger generation of artists to become themselves, that Soldner has left his most enduring legacy.

NOTES

Unless otherwise noted, all interviews were conducted by the author.

1. Interview with Bennett Bean, 16 July 1990.
2. Paul Soldner, Lecture, Scripps Humanities Institute, Claremont, Ca. 15 October 1990.
3. Soldner, statement in Scripps College Annual Report, Vol. 21. No. 1 (Winter 1985–86), p. 7.
4. Interview with Kris Cox, 13 July 1990.
5. Ibid.
6. Interview with Linda Rosenus Walsh, 14 November 1990.
7. Interview with Sana Krusoe, 15 November 1990.
8. Soldner, *Scripps College Annual Report*, p. 24.
9. Soldner, unpublished talk, n.d., p. 2.
10. Soldner, statements in "Paul Soldner: Thoughts on Creativity," video produced by the American Ceramic Society, 1989.
11. Interview with Rick Dillingham, 12 July 1990.
12. Interview with Phil Cornelius, 18 July 1990.
13. Interview with Norm Hines, 4 December 1990.
14. Soldner, "Raku as I Know It," *Ceramic Review* (1974).
15. Interview with Beth Changstrom, 15 November 1990.
16. Soldner, statement in Connie Ransom, "Renaissance Man: Paul Soldner," *Elan* (November 1990), p. 1.
17. Soldner, unpublished talk, n.d., p. 3.
18. Conversation with Soldner, 20 November 1990.
19. Soldner, Scripps Humanities Institute, 15 October 1990.
20. Conversation with Soldner, 27 November 1990.
21. Ibid.
22. Interview with Jun Kaneko, 11 July 1990.
23. Interview with Beverly Magennis, 10 July 1990.
24. Kaneko, 11 July 1990.
25. Interview with Bennett Bean, 16 July 1990.
26. Roslyn Siegel, "The Potters as Artist," *New York Times*, 21 February 1980.
27. Suzanne Muchnic, "The Galleries," *Los Angeles Times*, 26 September 1980.
28. Interview with Bean, 16 July 1990.
29. Interview with Magennis, 10 July 1990.
30. Interview with Dillingham, 12 July 1990.
31. Ransom, "Renaissance Man: Paul Soldner," p. 1.
32. Interview with Donna Nicholas, 11 July 1990.
33. Jane Fudge, "Under the Influence," *Artweek*, Vol 20, no. 13 (1 April 1989).

Glossary of Terms

bisque: Ware that has been fired once at a low temperature (usually at about cone 01, 1630°F) and is not glazed.

cone: Also called a pyrometric cone; a small, triangular object made of ceramic materials that acts as a thermometer. Cones are placed inside the kiln near a peephole so the cone can be used to evaluate conditions during firing. Each cone is given a number corresponding to a temperature at which it will collapse from heat in the kiln. Because it will melt at specific temperatures, the pyrometric cone helps the potter determine when a firing is complete. Temperatures below 2077°F are in the low range and are designated by cones with the prefix 0; those above 2077°F are in the high range and are signified by a number without a prefix. Cone 08 is approximately 1800°F; cone 10 is approximately 2400°F.

earthenware: Ware made of slightly porous opaque clay, usually red or tan in color, fired at low heat (below 2000°F).

kiln: A furnace designed for firing ceramic materials. There are many types of kilns, each serving different purposes with differing results. Some of the types mentioned in this essay are:

> *bottle kiln*: a kiln developed in Europe in the eighteenth century whose name describes its bottle shape and chimney top. The increased draft and fuel burning capacity of this design allowed potters to use higher temperatures necessary for the production of porcelain.

> *catenary-arch kiln:* a kiln whose spring arch is based on a catenary, a curve made by a chain hanging from two fixed points. When this line is inverted, the thrust is carried in the base, making the arch self supporting.

> *groundhog kiln:* so called because it is usually partly buried in the ground or against a hillside.

> *parabolic kiln:* a kiln whose arch is a parabolic curve.

Soldner's Aspen studio, 1975. On left: raku kiln with guillotine door for low-temperature firing. On right: catenary-arch kiln for high-temperature stoneware firing with oil fuel. Foreground: assorted drums for post-fire smoking

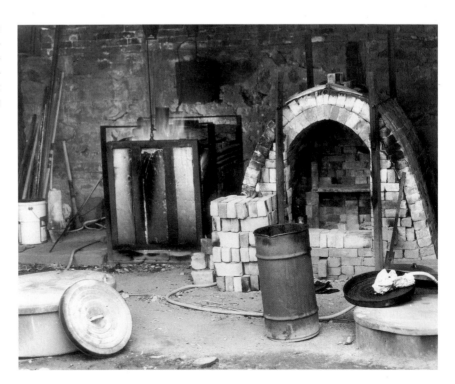

lead-based glaze: A glaze containing lead, which acts as a flux helping the glaze to melt at a low temperature.

low fire: Firing vessels at temperatures lower than 2000°F.

matte glaze: A glaze having a rough, granular surface rather than a smooth, glassy surface.

oxidation firing: An atmosphere within the kiln in which there is enough oxygen to completely burn the fuel.

oxide: Metal oxides used for coloring fired clay:

chromium oxide	gray-green
cobalt oxide	blue
copper oxide	green to black
iron oxide	brown
manganese dioxide	brown
rutile	yellow

porcelain blanks: Commercially produced plates ready to be decorated.

post-firing: A finishing process that follows the firing in a raku kiln. Ceramic pieces can be cooled in many different materials—water, grass, sawdust, etc.

raku clay: An open, porous clay body designed to withstand the thermal shock of fast firing and fast cooling.

raku ware: Ware made of a clay body that can withstand a high degree of thermal shock. After it has been bisqued (fired once) and glazed, it is placed in a small, red-hot kiln. The glaze matures in 15 to 20 minutes, and then the pot can be removed to cool.

reduction firing: An oxygen-starved atmophere within the kiln that takes oxygen away from metal oxides; the resulting carbon monoxide combines with oxygen from the body and glaze to form carbon dioxide, which produces color changes in oxides. Reduction firing also facilitates the integration of body and glaze in high-fired porcelain and stoneware.

salt firing: A method of firing using vaporized salt. Salt is thrown into the kiln at a high temperature or placed in the flame and fired at low temperature. When it vaporizes and combines with the silica in the clay body, a hard, glassy glaze or a soft, subtle surface is formed. Soldner fires with salt at a low temperature, equivalent to that used to produced bisque, rather than a high temperature. As a result, instead of a glassy glaze, his "salt-bisquing" as he calls it, produces soft blushes of peach and orange.

slip: Clay in liquid suspension. Slips with oxides are used for decorating clay with color.

stain: A colorant, sometimes made up of a single coloring oxide, but often a combination of oxides, added to alumina, flint, and a fluxing compound, for use in glaze, overglaze, and underglaze decoration.

stoneware: A hard, strong and nonporous ware that is high fired (above 2192°F).

terra sigillata: A slip that can produce a smooth, almost glossy surface.

throwing: Making pottery of plastic clay on a quickly rotating wheel.

wax resist: A decorative technique wherein liquid wax is brushed onto the surface of clay, which prevents an applied stain or glaze from adhering to the decorated portions.

Checklist of the Exhibition

Arranged chronologically.

1. *Bottle* (41-1), 1941
 Wheel-thrown, earthenware, low-fire iron-bearing glaze, oxidation firing, cone 06
 4 ³/₄ x 3 ¹/₄ x 3 ¹/₄ in.
 Private Collection, Aspen

2. *Bottle* (54-2), 1954
 Wheel-thrown, stoneware, high-temperature rutile glaze, reduction firing, cone 10
 22 ³/₄ x 5 in.
 Private Collection, Aspen

3. *Covered Jar*, 1955
 Wheel-thrown, stoneware, polychrome oxide decoration, semi-matte glaze, reduction firing, cone 10
 21 x 8 in.
 Jennifer Coile, Los Angeles

4. *Covered Jar* (55-1), 1955
 Wheel-thrown, stoneware, polychrome slip, oxide decoration, wax resist, rutile matte glaze, reduction firing, cone 10
 20 x 11 ¹/₂ in.
 Private Collection, Aspen

5. *Vase*, c. 1955
 Wheel-thrown, stoneware, polychrome oxide decoration, reduction firing, cone 10
 13 x 9 x 12 in.
 Mr. and Mrs. Samuel Skolnik, Los Angeles

6. *Floor Pot* (56-1), c. 1956
 Wheel-thrown, stoneware, extended technique, polychrome oxide decoration, white glaze, reduction firing, cone 10
 52 ¹/₂ x 9 in.
 Private Collection, Aspen

7. *Samovar* (57-1), 1957
 Wheel-thrown, stoneware, slip decoration, white matte textured glaze, reduction firing, cone 10
 18 ¹/₂ x 13 in.
 Private Collection, Aspen, Co.

8. *Vase* (58-2), 1958
 Wheel-thrown, stoneware, white slip and cobalt oxide decoration, clear glaze, reduction firing, cone 10
 13 ¹/₄ x 7 ¹/₂ x 6 in.
 Private Collection, Aspen

9. *Vase*, c. 1958
 Wheel-thrown, stoneware, applied clay decoration, clear glaze, reduction firing, cone 10
 23 x 14 in.
 Sam and Alfreda Maloof, Alta Loma, Ca.

10. *Floor Pot* (59-1), 1959
 Wheel-thrown, stoneware, extended technique, iron and cobalt decoration, wax resist, clear glaze, reduction firing, cone 10
 55 x 12 in.
 Doug Lawrie, Atascadero, Ca.

11. *Floor Pot*, 1959
 Wheel-thrown, stoneware, extended technique, polychrome slip and oxide decoration, reduction firing, cone 10
 48 x 15 in.
 O. Louis Wille, Aspen

12. *Tea Bowl* (64-1), 1964
 Wheel-thrown, stoneware, raku clay, iron and copper oxide, low-temperature clear crackle and lustre glaze, post-fire smoking, cone 08
 3 ¹/₄ x 5 in.
 Private Collection, Aspen

13. *Bottle*, 1964
 Wheel-thrown and altered, raku clay, white slip, iron and copper decoration, post-fire smoking, cone 08
 9 x 7 in.
 Everson Museum of Art, Syracuse, N.Y.

14. *Vase*, c.1964
 Wheel-thrown and altered, raku clay, white slip, iron and copper oxideclear glaze,post-fire smoking, cone 08
 8 ³/₄ x 8 ¹/₂ in.
 American Craft Museum, New York

15. *Vase*, 1965
 Wheel-thrown and altered, raku clay, white slip, iron and copper decoration, unglazed, post-fire smoking with reoxidation for halo effect, cone 08
 16 ¹/₂ x 14 ¹/₅ x 14 ¹/₄ in.
 Scripps College, Claremont
 Gift of Fred and Estelle Marer

16. *Wall Piece*, 1969 (69-1)

Hand-built, raku clay, white slip, iron and copper brushwork, glassy red glaze, post-fire smoking, cone 08

19 x 24 in.

Bernard and Joan Bloom, Boulder

17. *Wall Piece (Black is Beautiful)*, c. 1969

Hand-built, raku clay, white slip, unglazed, template decoration, post-fire smoking, cone 08

22 x 19 in.

Private Collection, Aspen, Co.

18. *Wall Piece (John Lennon and Playboy)*, 1969

Hand-built, raku clay, white and copper slips, cobalt oxide, clear glaze, post-fire smoking, cone 08

25 1/4 x 18 1/2 x 3 1/4 in.

Marer Collection
Scripps College, Claremont

19. *Wall Piece (Self-Examination)* (71-1), 1971

Hand-built, raku clay, polychrome decoration, unglazed, template impression, post-fire smoking, cone 08

25 x 20 1/2 x 3 in.

Private Collection, Aspen

20. *Vessel* (72-1), 1972

Wheel-thrown and altered, raku clay, polychrome slip decoration, unglazed, stencil design, post-fire smoking, cone 08

14 x 10 x 8 1/2 in.

Marcia Cowee, Aspen

21. *Vessel*, c. 1972

Wheel-thrown and altered, raku clay, copper slip over white slip, unglazed, drawn figures, post-fire smoking, cone 08

15 x 13 x 11 1/2 in.

Contemporary Crafts Association, Portland

22. *Vessel*, 1973

Wheel-thrown and altered, raku clay, white slip, iron and copper brushwork, unglazed, post-fire smoking, cone 08

18 x 16 in.

Tom Benton, Aspen

23. *Vessel*, 1974

Wheel-thrown and altered, raku clay, white slip, iron and copper oxide, clear glaze, post-fire smoking, cone 08

19 1/2 x 6 1/2 in.

Bernard and Joan Bloom, Boulder

24. *Bottle*, 1974

Wheel-thrown and altered, raku clay, white slip, iron and copper oxide brushwork, unglazed, post-fire smoking, cone 08

21 1/4 x 7 1/2 in.

Scripps College, Claremont
Gift of Dr. and Mrs. Burton D. Thuma

25. *Plaque*, 1974

Wheel-thrown and altered, raku clay, white and copper slips, clear glaze, template decoration, post-fire smoking, cone 08

20 x 21 1/2 x 3 1/2 in.

Scripps College, Claremont
Gift of Fred and Estelle Marer

26. *Vessel*, 1975

Wheel-thrown and altered, raku clay, white slip, iron and copper brushwork, unglazed, post-fire smoking, cone 08

13 x 12 in.

Bernard and Joan Bloom, Boulder

27. *Platter*, 1975

Wheel-thrown, raku clay, iron and copper brushwork, partially glazed, low-temperature salt-vapor fired, cone 08

15 x 15 in.

Robert and Pat Chapman, Mt. Baldy, Ca.

28. *Vessel*, 1975

Wheel-thrown and altered, raku clay, copper-flashed, unglazed, low-temperature salt-vapor fired, cone 08

12 x 10 in.

Lynne Wagner, Sayville, N.Y.

29. *Vessel* (76-1), 1976

Wheel-thrown and altered, raku clay, white slip with copper slip stencil, unglazed, post-fire smoking, cone 08

10 x 15 x 9 in.

Aldo and Judy Casanova, Claremont

30. *Vessel*, c. 1976

Wheel-thrown and altered, raku clay, white slip, unglazed, post-fire smoking, cone 08

21 x 11 in.

Sam and Alfreda Maloof, Alta Loma, Ca.

31. *Wall Piece (Clairol Ladies)* (78-1), 1978

Hand-built, raku clay, white slip and copper stencil, partially glazed, post-fire smoking, cone 08

17 1/2 x 26 x 3 1/2 in.

Private Collection, Aspen

32. *Pedestal Piece (78-2)*, 1978
Wheel-thrown and altered, raku clay, white slip
with clear glaze, stenciled figures, post-fire
smoking, cone 08
22 x 7 x 7 in.
Private Collection, Aspen

33. *Teapot (78-3)*, 1978
Wheel-thrown, stoneware, white slip,
salt glaze, cone 10
10 1/2 x 8 1/2 x 8 in.
Private Collection, Aspen

34. *Vessel (Madonna)*, c. 1979
Wheel-thrown and altered, raku clay, white
and copper slip, iron and copper oxide
decoration, clear glaze, post-fire
smoking, cone 08
21 x 8 1/2 in.
Bernard and Joan Bloom, Boulder

35. *Wall Piece (Bird of Paradise) (79-2)*, 1979
Kiln shelf, white slip base with copper slip
over stencil, partially glazed, post-fire light
smoking, cone 08
7 x 8 x 1/2 in.
Private Collection, Aspen

36. *Wall Piece (Division)*, 1979
Hand-built, raku clay, white and copper slips,
stenciled figures, partially glazed,
low-temperature salt-vapor fired,
post-fire smoking, cone 08
23 x 19 in.
Dr. and Mrs. Malcolm Nanes, New York

37. *Wall Piece*, 1979
Hand-built, raku clay, white slip, stenciled figures,
thin clear glaze, low-temperature salt-bisqued,
post-fire smoking, cone 08
22 x 22 in.
Garrett Sullivan and Stephanie Soldner Sullivan,
Denver

38. *Vase*, 1980
Wheel-thrown and altered, raku clay, iron
and copper brushwork, unglazed,
low-temperature salt-vapor fired, cone 08
18 x 5 x 6 1/2 in.
Howard and Gwen Laurie Smits, Montecito, Ca.

39. *Vessel*, c. 1980
Wheel-thrown and altered, raku clay, white
and copper slips, stenciled figures, clear glaze,
post-fire smoking, cone 08
20 x 13 in.
Bernard and Joan Bloom, Boulder

40. *Pedestal Piece (81-18)*, 1981
Wheel-thrown and altered, raku clay, white
slip base with copper slip over stencil, partially
glazed, low-fire salt-bisqued,
light post-fire smoking, cone 08
18 x 10 x 8 in.
Lee and Joanne Lyon, Aspen

41. *Pedestal Piece (82-63)*, 1982
Wheel-thrown and altered, raku clay, unglazed,
low-temperature salt-vapor fired, cone 08
10 1/4 x 9 x 6 in.
Private Collection, Aspen

42. *Pedestal Piece (82-121)*, 1982
Wheel-thrown and altered, raku clay, unglazed,
low-temperature salt-vapor fired, cone 08
20 1/2 x 23 x 7 in.
High Museum of Art, Atlanta,
Gift of W. Dean Gillette and Gerald R. Frutchey

43. *Wall Piece*, 1982
Wheel-thrown and altered, raku clay,
unglazed, cone 08
17 1/2 x 30 x 4 in.
Fred and Estelle Marer, Los Angeles

44. *Pedestal Piece (83-16)*, 1983
Wheel-thrown and altered, raku clay, unglazed,
low-temperature salt-vapor fired, cone 08
12 x 14 1/2 x 8 1/2 in.
Charlene Felos, Huntington Beach, Ca
(not in exhibition)

45. *Pedestal Piece (83-19)*, 1983
Wheel-thrown and altered, raku clay, white
slip unglazed, steam dried, low-temperature
salt-vapor fired, cone 08
14 x 20 x 8 in.
The Art Works, Riverside, Ca.

46. *Pedestal Piece (83-28)*, 1983
Wheel-thrown and altered, raku clay, unglazed,
low-temperature salt-vapor fired, cone 08
16 1/2 x 25 x 8 1/4 in.
Mr. and Mrs. Truman Chaffin, Los Angeles

47. *Pedestal Piece (83-90)*, 1983
Wheel-thrown and altered, raku clay,
low-temperature salt-vapor fired, cone 08
18 x 21 in.
The Chubb Corporation, Newark
(not illustrated)

48. *Pedestal Piece* (84-28), 1984
Wheel-thrown and altered, raku clay, polychrome slips, iron and copper oxide brushwork, low-temperature salt-vapor fired, cone 08
17 x 13 x 5 in.
Fred and Estelle Marer, Los Angeles

49. *Pedestal Piece* (84-49), 1984
Wheel-thrown and altered, raku clay, copper slip, low-temperature salt-vapor fired, cone 08
20 ¹/₂ x 13 ¹/₂ x 8 in.
Mr. and Mrs. Truman Chaffin, Los Angeles

50. *Wall Piece* (84-66), 1984
Hand-built, raku clay, unglazed, low-temperature salt-vapor fired, cone 08
20 x 28 in.
Mr. and Mrs. Glen Hampton, Pasadena

51. *Wall Piece* (84-68), 1984
Hand-built, raku clay, white and copper slips, iron and copper oxides, partially glazed, low-temperature salt-vapor fired, cone 08
23 x 16 ¹/₂ in.
Garrett Sullivan and Stephanie Soldner Sullivan, Denver

52. *Pedestal Piece* (84-69), 1984
Wheel-thrown and altered, raku clay, unglazed, lead addition, low-temperature, salt- and oil-vapor fired, cone 08
18 ¹/₂ x 4 ¹/₂ in.
Garrett Sullivan and Stephanie Soldner Sullivan, Denver

53. *Vessel* (84-82), 1984
Wheel-thrown and altered, raku clay, white slip base, iron and copper oxide brushwork, post-fire smoking, cone 08
20 ¹/₂ x 6 x 5 ¹/₂ in.
Private Collection, Aspen

54. *Pedestal Piece*, 1984
Wheel-thrown and altered, raku clay, white, green and copper slips, glazed, post-fire smoking, cone 08
11 x 11 in.
Nikki Joy Jackson, Claremont

55. *Wall Piece*, 1984
Wheel-thrown and altered, raku clay, unglazed, low-temperature salt-vapor fired, cone 08
20 x 28 in.
Private Collection, Aspen

56. *Wall Piece* (85-6), 1985
Hand-built, raku clay, white and copper slips over stencil, partially glazed, low-temperature salt-vapor fired, cone 08
23 ¹/₂ x 27 in.
Private Collection, Aspen

57. *Wall Piece (Marlboro Man)* (85-10), 1985
Hand-built, raku clay, white and copper slips over stencil, partially glazed, low-temperature salt-vapor fired, cone 08
27 x 21 in.
Mike and Connie Layne, Claremont

58. *Pedestal Piece* (85-15), 1985
Wheel-thrown and altered, raku clay, white slip, unglazed, low-temperature salt-vapor fired, cone 08
22 x 25 x 5 ¹/₂ in.
Pamela Leeds, Los Angeles

59. *Wall Piece (Valentine)* (85-29), 1985
Hand-built, raku clay, polychrome slip, partially glazed, low-temperature salt-vapor fired, cone 08, post-fire oxyacetylene drawing with bronze crack
21 x 26 in.
Ginny Soldner, Aspen

60. *Pedestal Piece* (85-38), 1985
Wheel-thrown and altered, raku clay, copper slip, low-temperature salt-vapor fired, cone 08
25 ¹/₂ x 14 ¹/₂ in.
Mr. and Mrs. Christopher D. Sickels

61. *Pedestal Piece*, 1985
Wheel-thrown and altered, raku clay, copper manganese slip, low-temperature salt-vapor fired, cone 08
32 x 36 x 10 ¹/₂ in.
Marer Collection
Scripps College, Claremont

62. *Wall Piece* (86-14), c. 1986
Wheel-thrown and altered, raku clay, unglazed, lead and bronze additions, oxyacetylene torch decoration, low-temperature salt-vapor fired, cone 08
24 x 28 in.
Private Collection, Altadena, Ca.

63. *Pedestal Piece* (86-20), 1986
Wheel-thrown and altered, raku clay, unglazed, low-temperature salt-vapor fired, cone 08
24 ¹/₂ x 30 x 3 in.
Prudential Insurance Company of America
(not illustrated)

64. *Wall Piece (86-38)*, 1986
Aluminum
23 x 25 x 5 in.
Private Collection, Aspen

65. *Pedestal Piece (87-6)*, 1987
Wheel-thrown and altered, raku clay, copper
slip, unglazed, low-temperature salt-vapor
fired, cone 08
28 3/4 x 38 x 12 1/2 in.
Gerald and Lynn Myers, Pasadena

66. *Pedestal Piece (87-7)*, 1987
Wheel-thrown and altered, raku clay, copper slip,
unglazed, low-temperature salt-vapor fired,
cone 08
19 x 37 x 18 in.
David and Pamela Banks, Pasadena

67. *Pedestal Piece (87-12)*, 1987
Wheel-thrown and altered, raku clay, unglazed,
terra sigillata, low-temperature salt-vapor
fired, cone 08
32 x 37 x 13 in.
Louis Newman Galleries, Beverly Hills

68. *Pedestal Piece (87-15)*, 1987
Wheel-thrown and altered, raku clay, unglazed
low-temperature, salt-vapor fired, cone 08
23 x 38 x 12 1/2 in.
Arkansas Art Center Foundation Collection,
Little Rock

69. *Pedestal Piece (88-7)*, 1988
Wheel-thrown and altered, raku clay,
polychrome slips, low-temperature
salt-vapor fired, cone 08
22 1/2 x 33 x 7 1/2 in.
Sangre de Christo Arts and Conference Center,
Pueblo, Co.

70. *Pedestal Piece (88-24)*, 1988
Wheel-thrown and altered, raku clay,
copper slip, unglazed, surface textured,
low-temperature salt-vapor fired, cone 08
29 1/2 x 41 x 8 in.
Charles and Beverly Diamond, Newport Beach, Ca.

71. *Pedestal Piece (89-7)*, 1989
Wheel-thrown and altered, raku clay, copper slip,
unglazed, low-temperature salt-vapor fired,
cone 08
28 x 45 in.
Scripps College, Claremont,
Gift of the Fine Arts Foundation

72. *Pedestal Piece (89-10)*, 1989
Bronze with dark brown patina
24 x 32 in.
Dave Philips, Riverside, Ca.

73. *Pedestal Piece (90-12)*, 1990
Wheel-thrown and altered, raku clay, unglazed,
low-temperature salt-vapor fired, cone 08
18 x 37 x 8 in.
Louis Newman Galleries, Beverly Hills

74. *Pedestal Piece (90-13)*, 1990
Bronze with silver patina
23 1/4 x 36 x 13 in.
Private Collection, Aspen

Catalogue

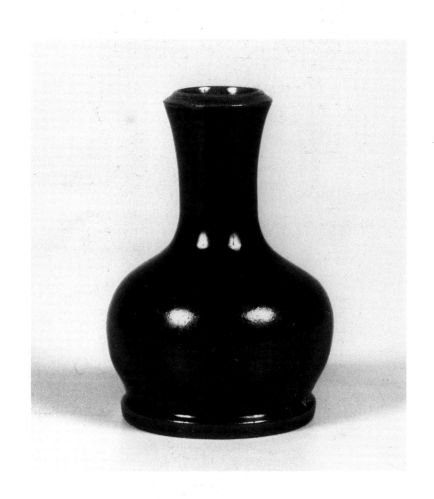

Bottle (41-1), 1941
CHECKLIST NO. 1

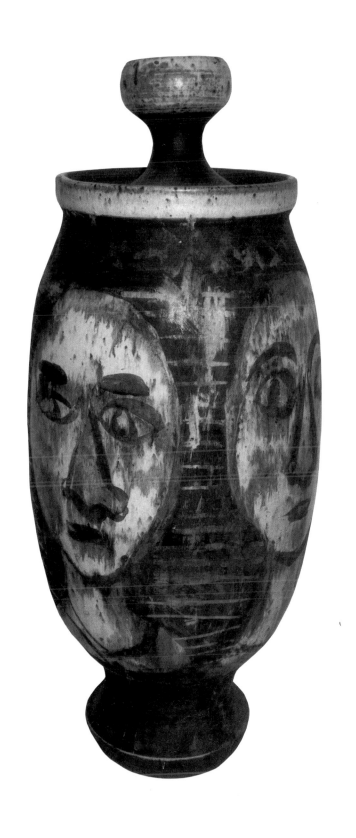

Covered Jar, **1955**
CHECKLIST NO. 3

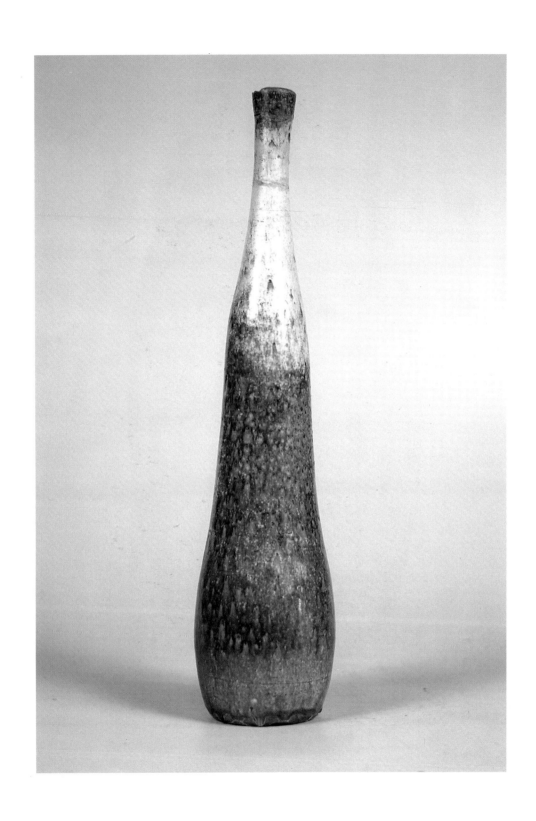

Bottle (54-2), 1954
CHECKLIST NO. 2

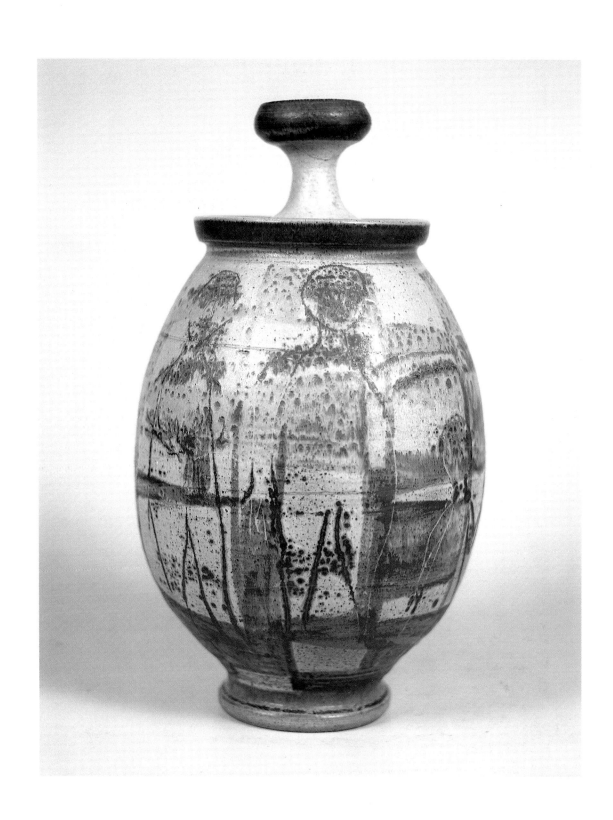

Covered Jar (55-1), **1955**
CHECKLIST NO. 4

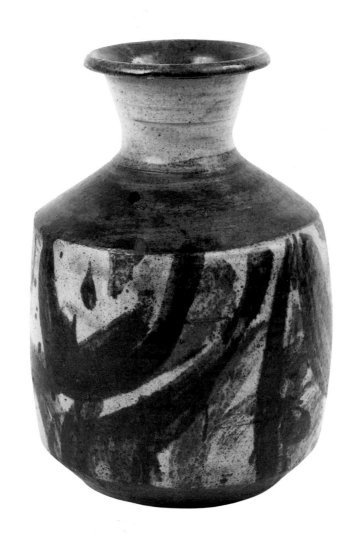

Vase, c. 1955
CHECKLIST NO. 5

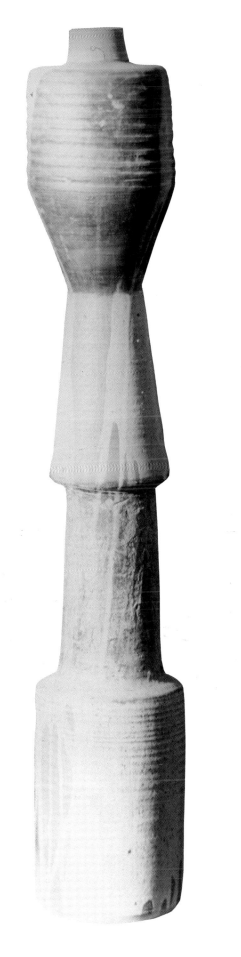

Floor Pot (56-1), c. 1956
CHECKLIST NO. 6

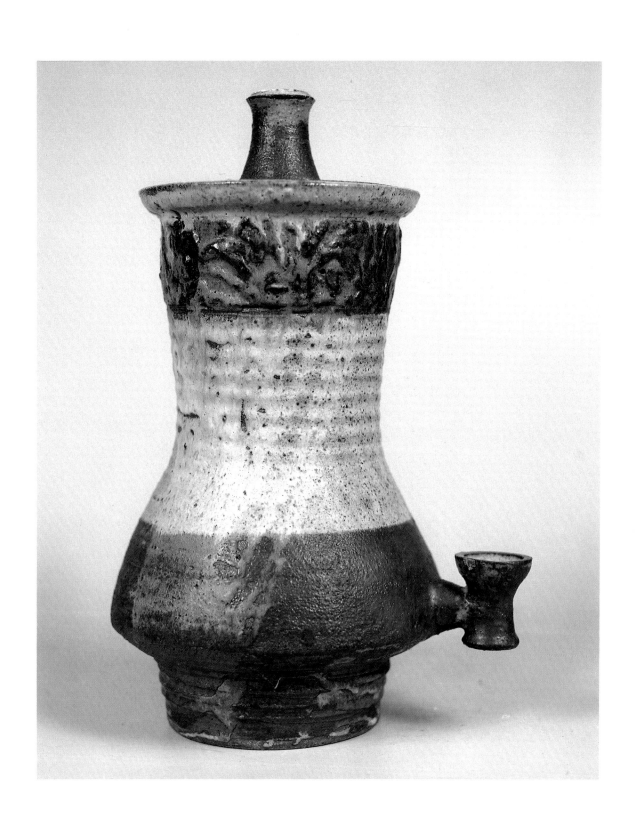

Samovar (57-1), 1957
CHECKLIST NO. 7

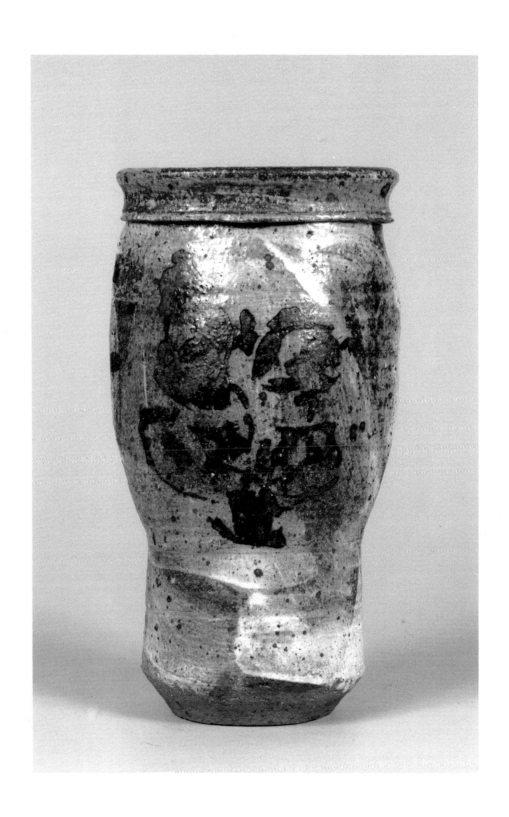

Vase (58-2), 1958
CHECKLIST NO. 8

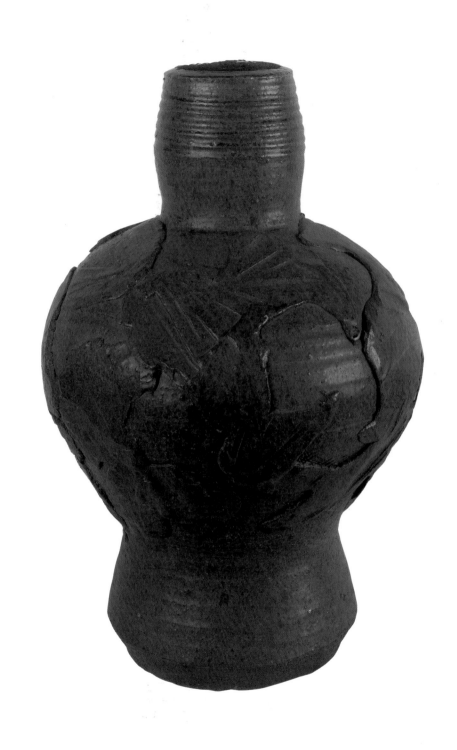

Vase, c. **1958**
CHECKLIST NO. 9

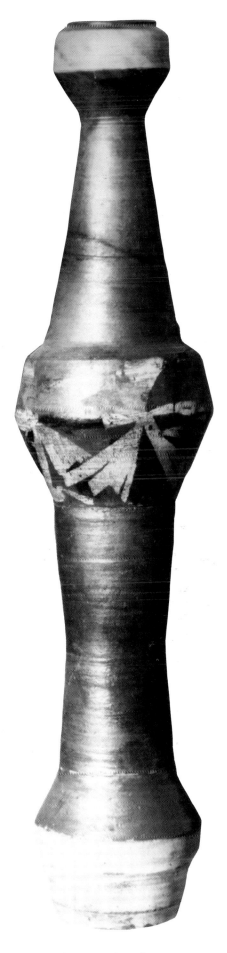

Floor Pot (59-1), 1959
CHECKLIST NO. 10

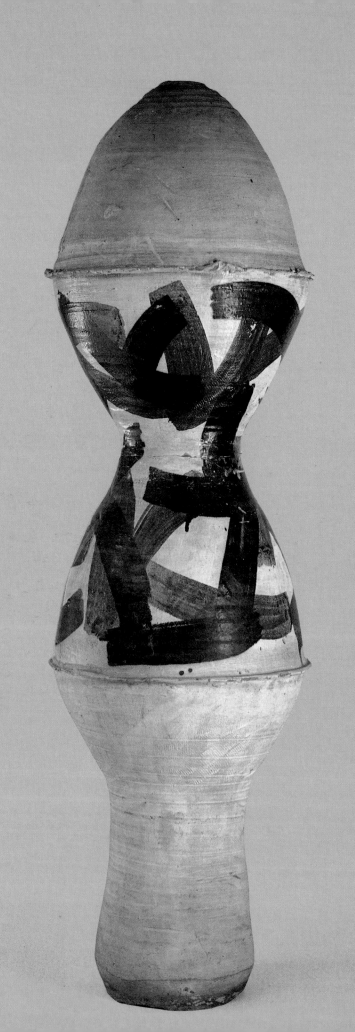

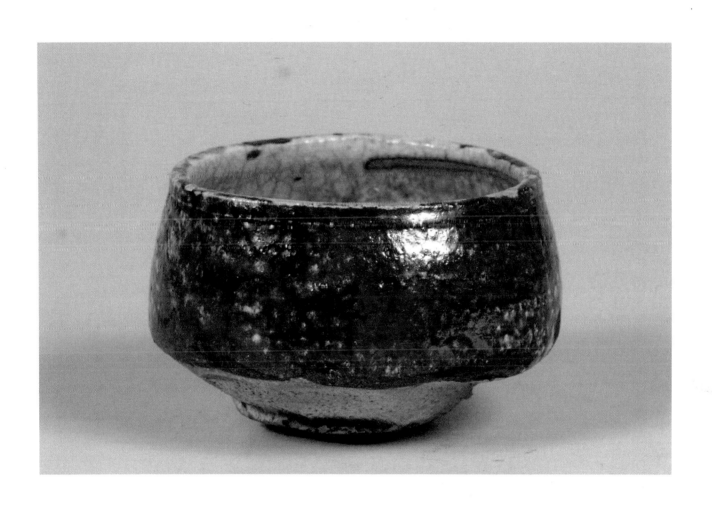

◄ *Floor Pot*, 1959
CHECKLIST NO. 11

Tea Bowl (64-1), 1964
CHECKLIST NO. 12

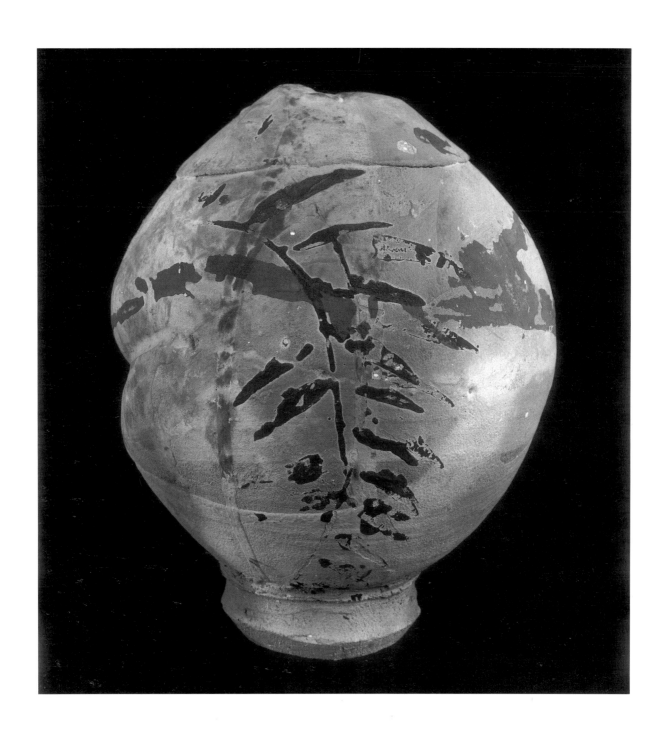

Bottle, 1964
CHECKLIST NO. 13

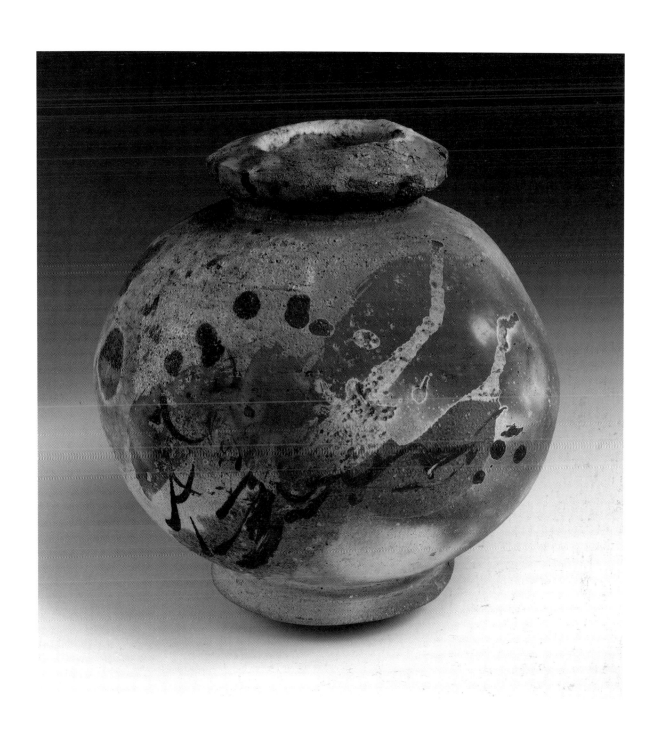

Vase, c. 1964
CHECKLIST NO. 14

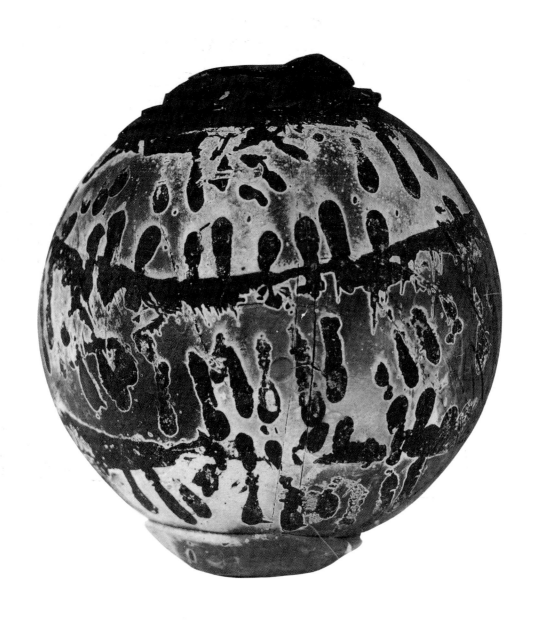

Vase, 1965
CHECKLIST NO. 15

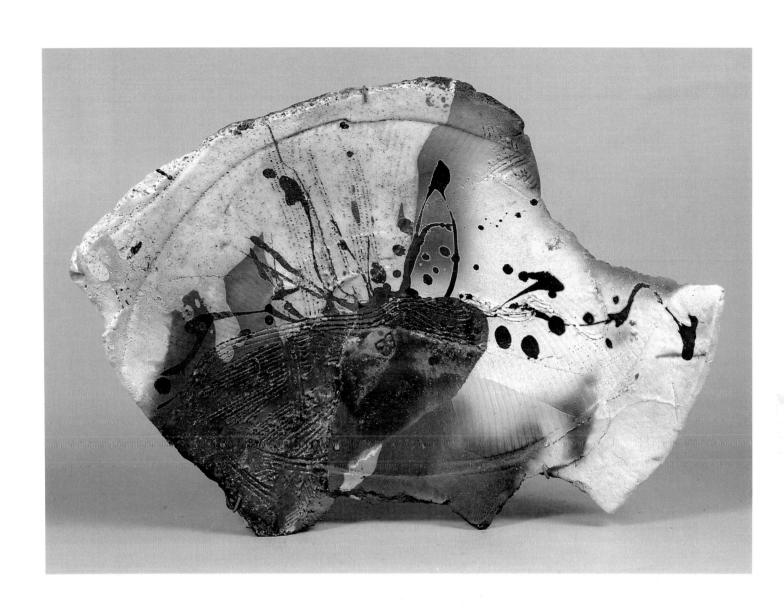

*Wall Piece, (69-1)*1969
CHECKLIST NO. 16

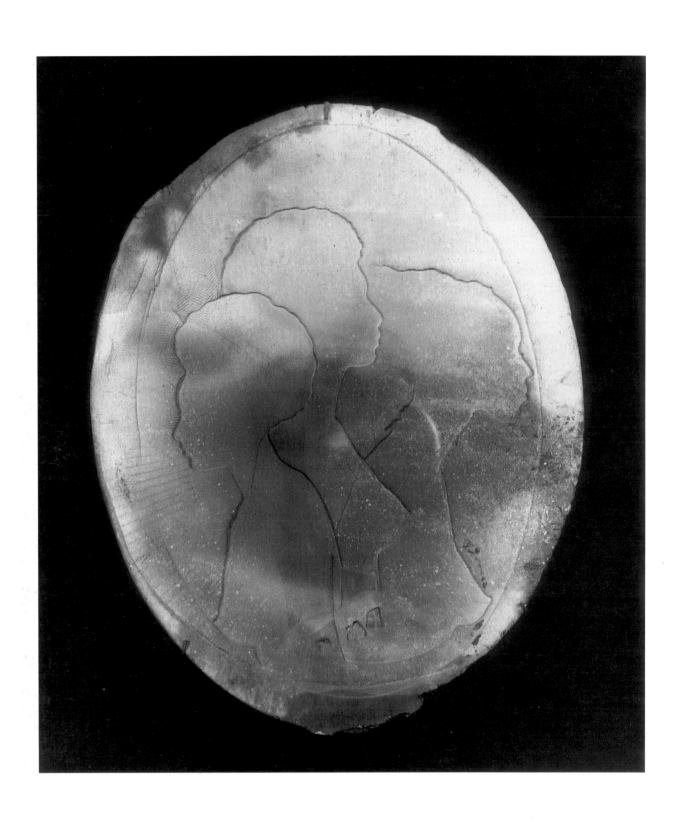

Wall Piece (Black is Beautiful), c. 1969
CHECKLIST NO. 17

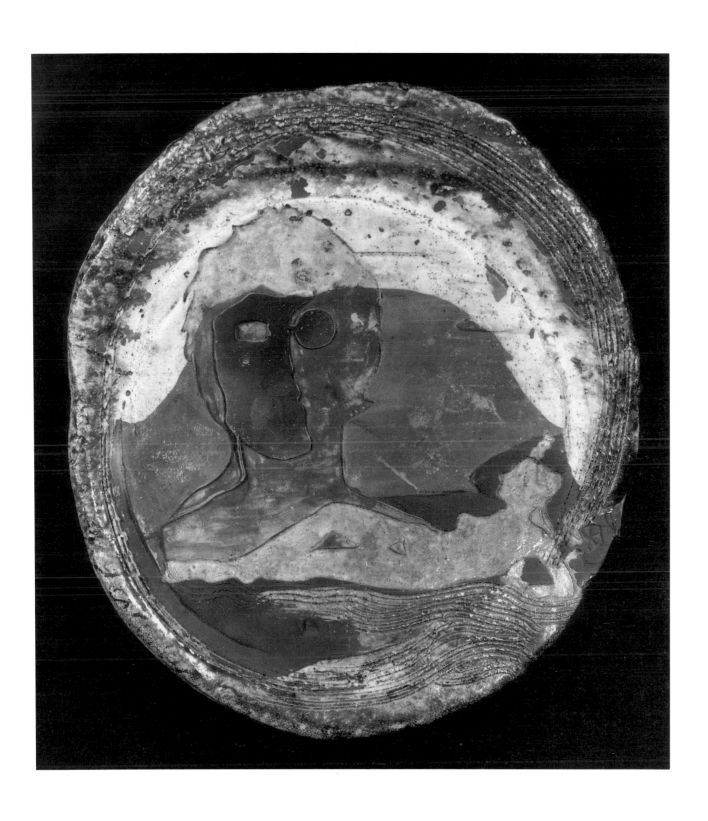

Wall Piece (John Lennon and Playboy), 1969
CHECKLIST NO. 18

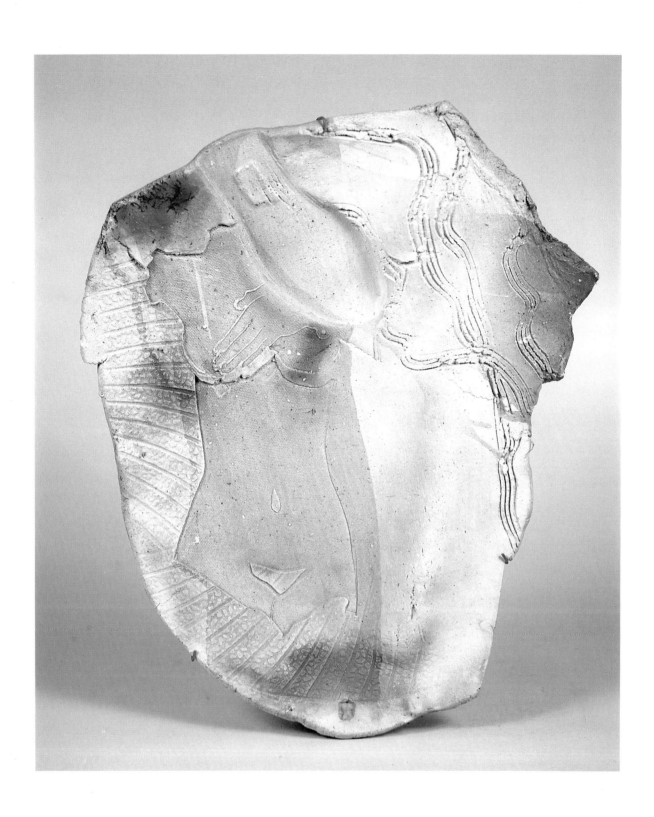

Wall Piece (Self-Examination) (71-1), 1971
CHECKLIST NO. 19

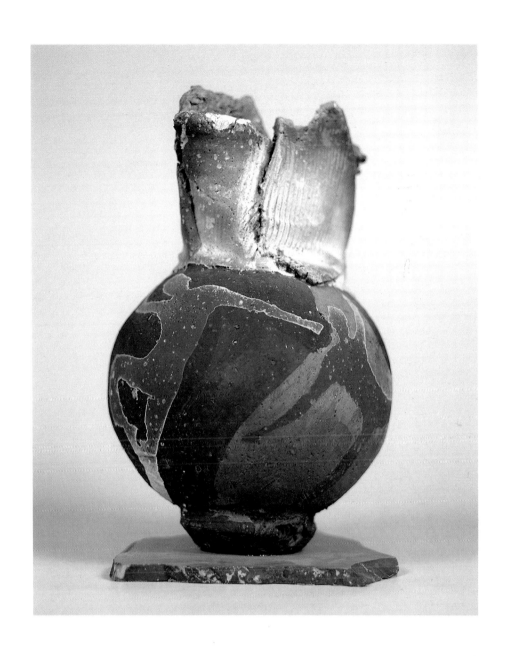

Vessel (72-1), 1972
CHECKLIST NO. 20

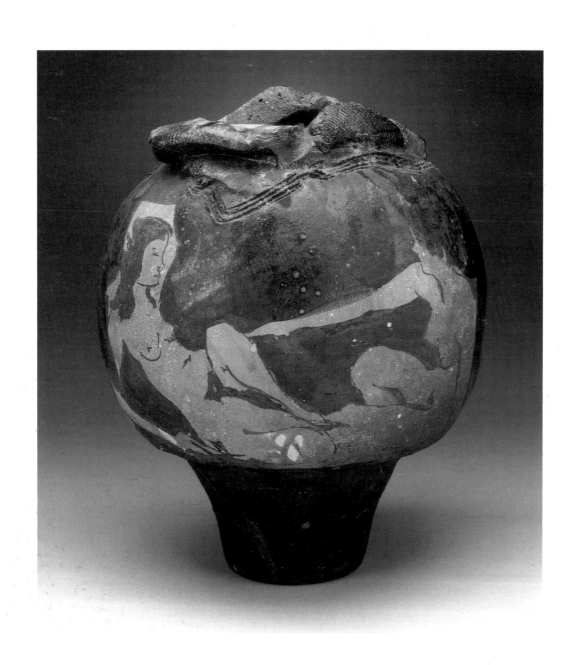

Vessel, c. 1972
CHECKLIST NO. 21

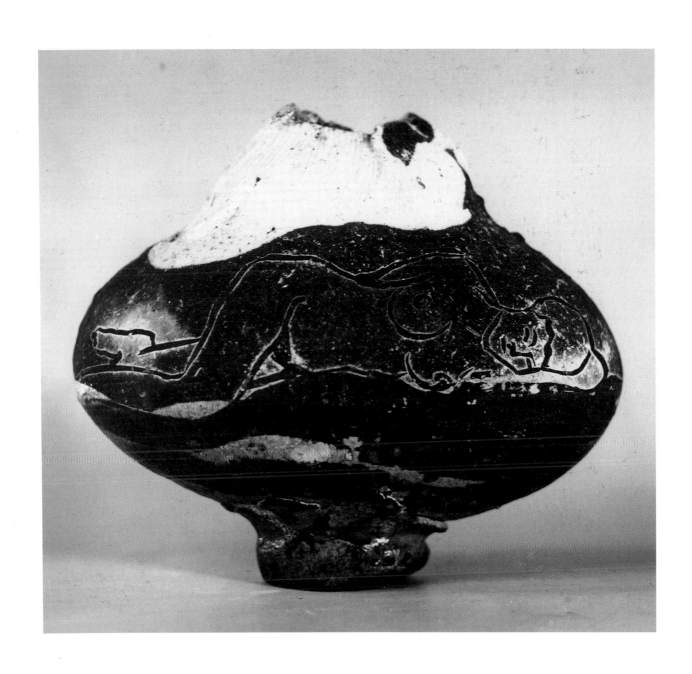

Vessel, 1973
CHECKLIST NO. 22

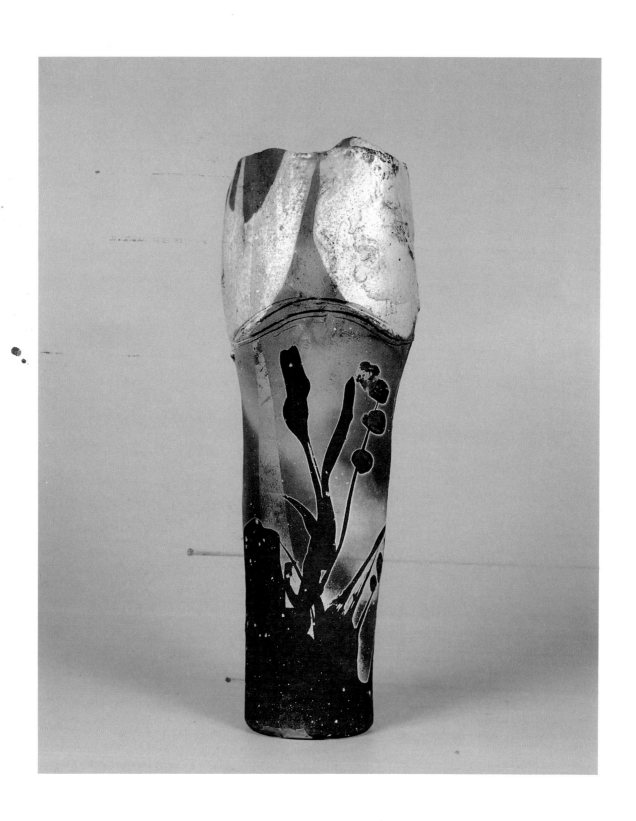

Vessel, 1974
CHECKLIST NO. 23

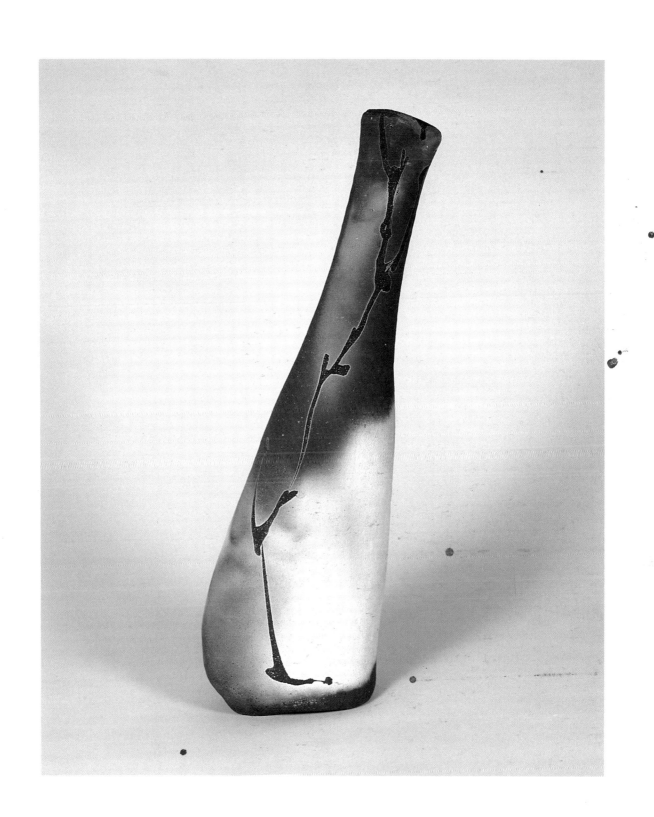

Bottle, 1974
CHECKLIST NO. 24

Plaque, 1974
CHECKLIST NO. 25

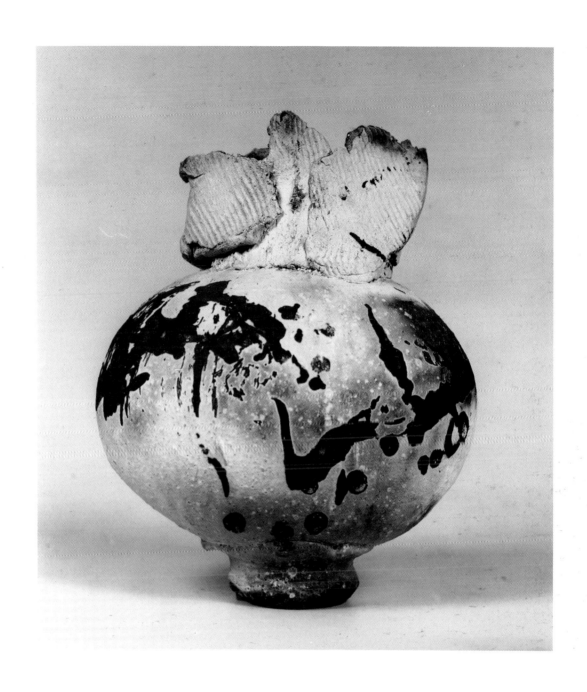

Vessel, 1975
CHECKLIST NO. 26

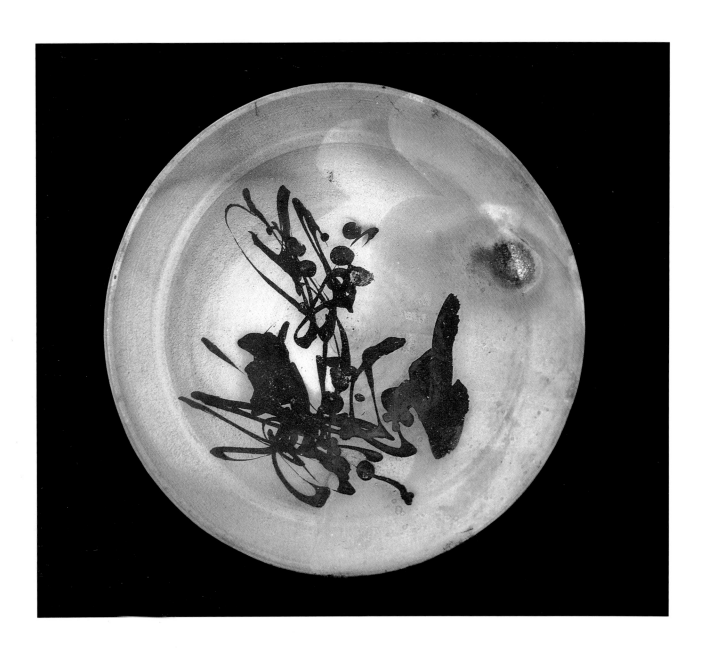

Platter, 1975
CHECKLIST NO. 27

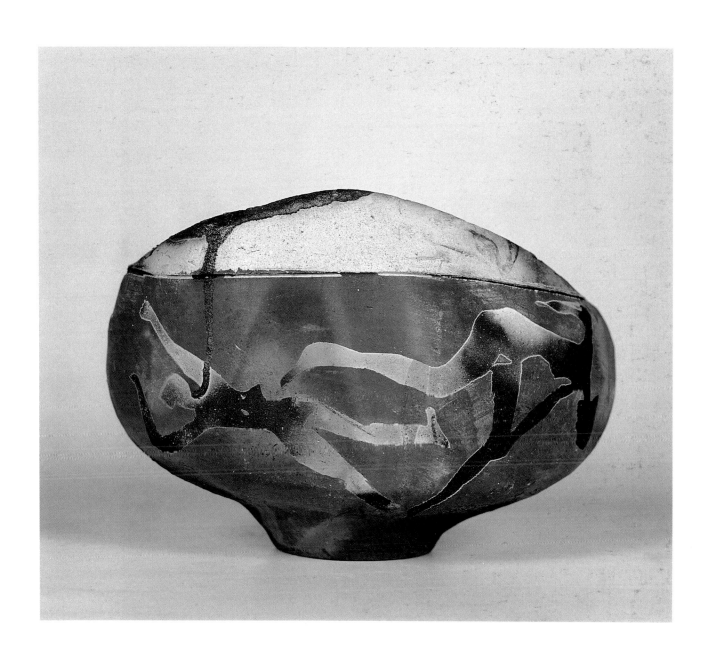

Vessel (76-1), 1976
CHECKLIST NO. 29

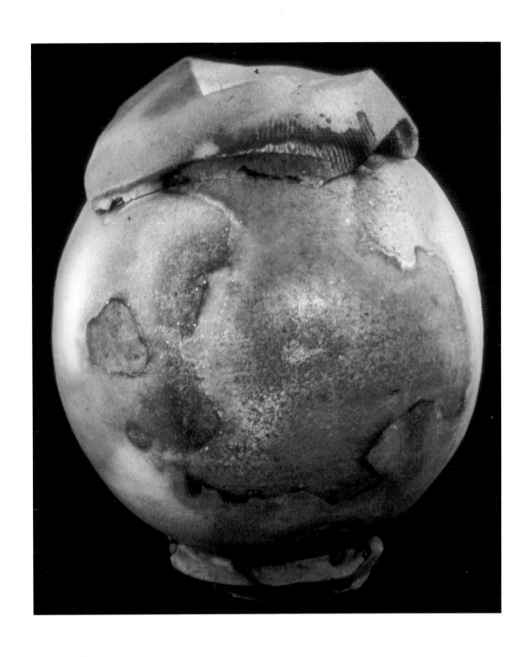

Vessel, 1975
CHECKLIST NO. 28

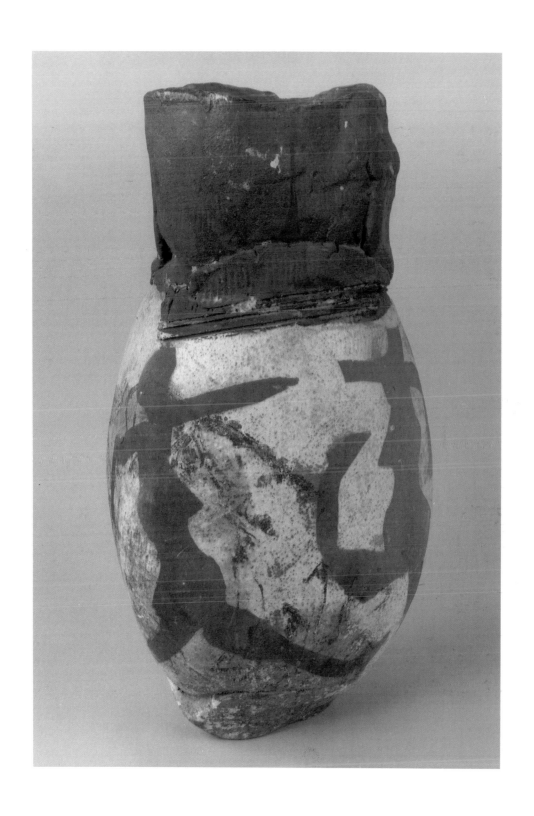

Vessel, c. 1976
CHECKLIST NO. 30

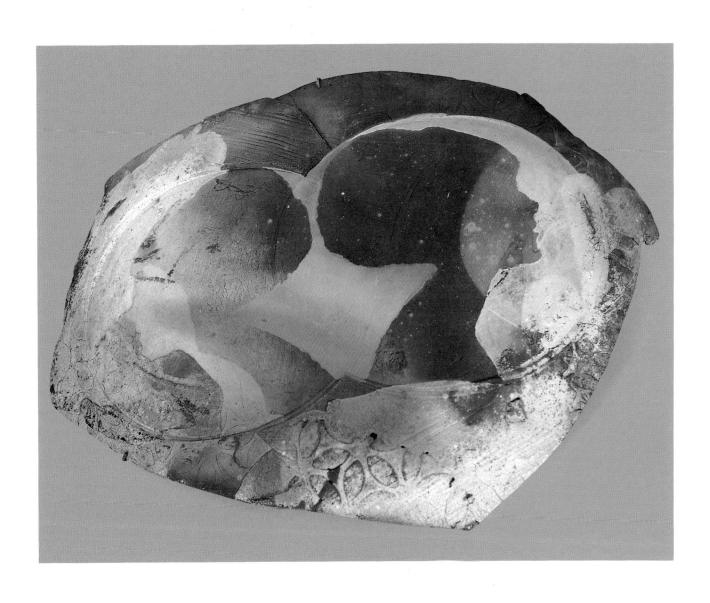

Wall Piece (Clairol Ladies) (78-1), 1978
CHECKLIST NO. 31

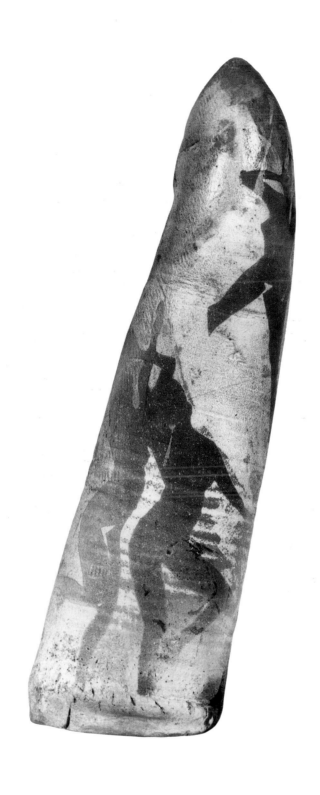

Pedestal Piece (78-2), 1978
CHECKLIST NO. 32

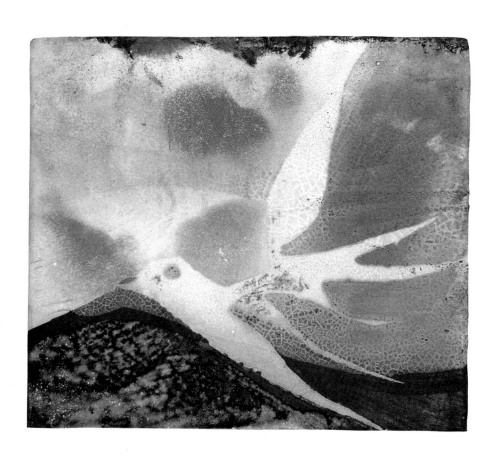

Wall Piece (Bird of Paradise) (79-2), 1979
CHECKLIST NO. 35

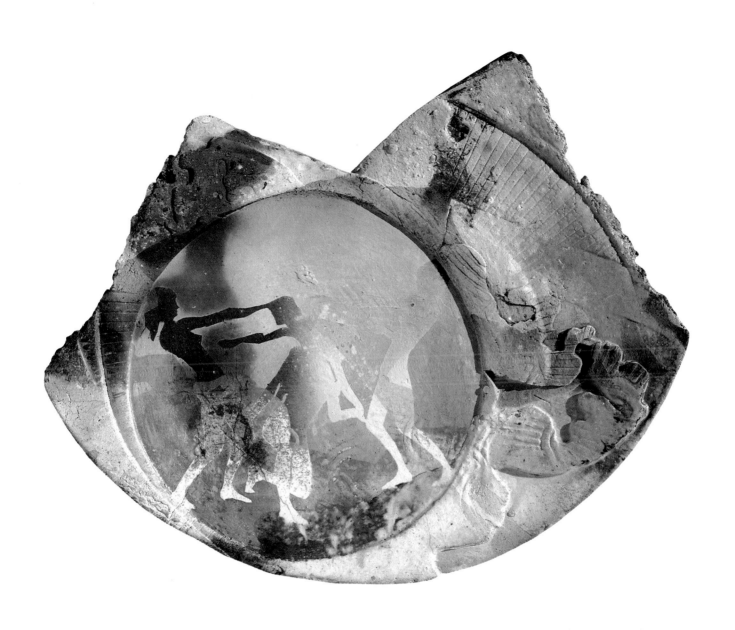

Wall Piece (Division), 1979
CHECKLIST NO. 36

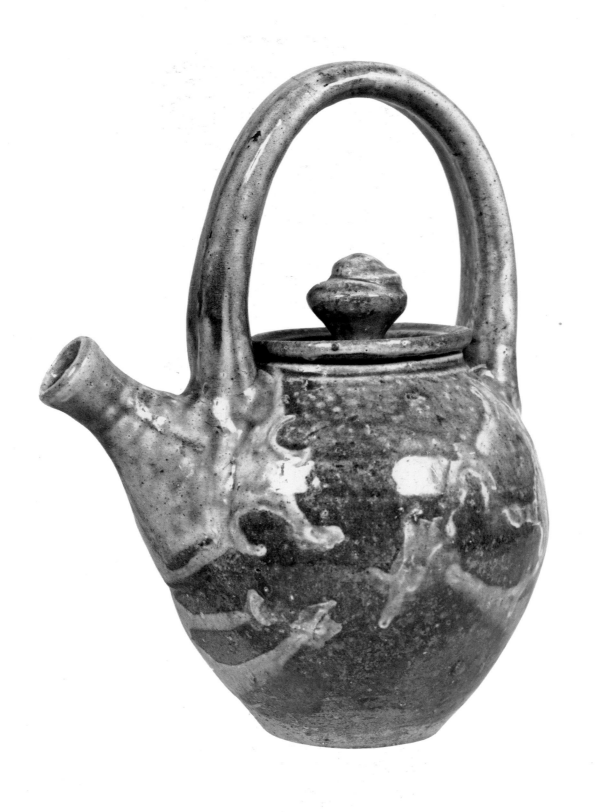

Teapot (78-3), 1978
CHECKLIST NO. 33

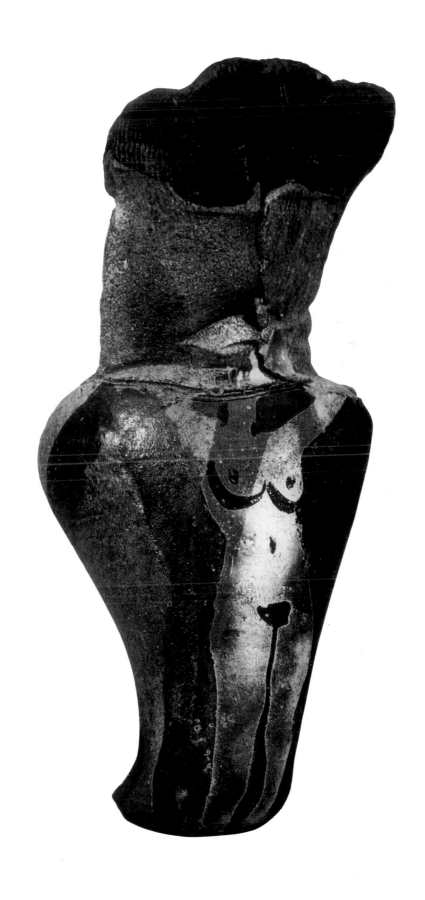

Vessel (Madonna), c. 1979
CHECKLIST NO. 34

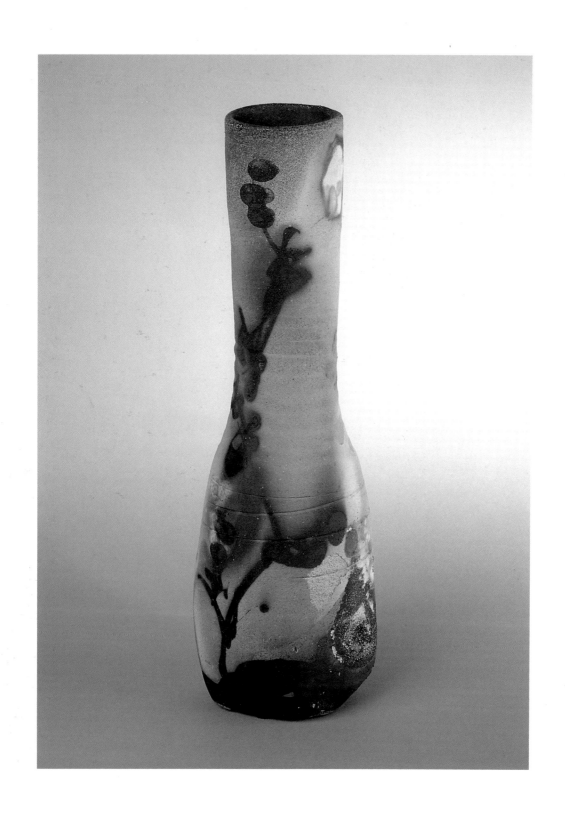

Vase, 1980
CHECKLIST NO. 38

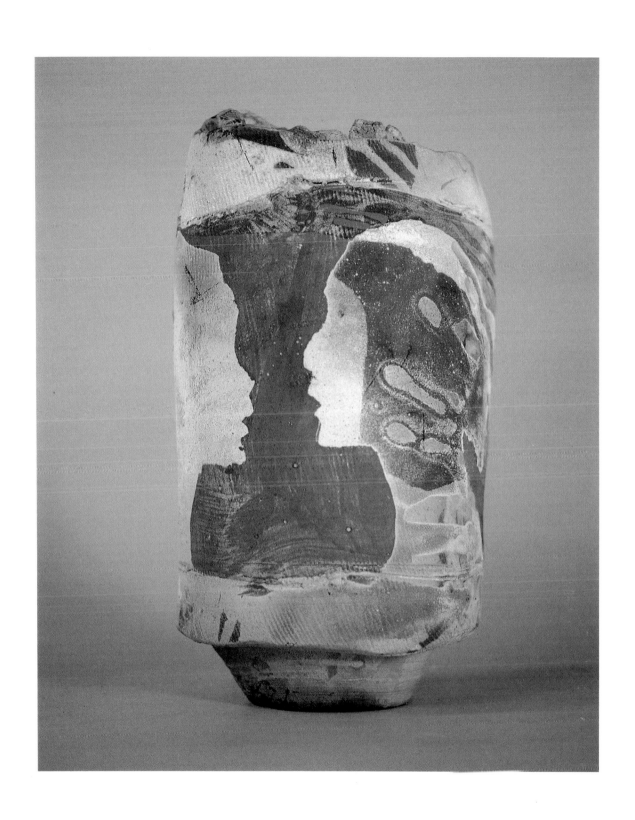

Pedestal Piece (81-18), **1981**
CHECKLIST NO. 40

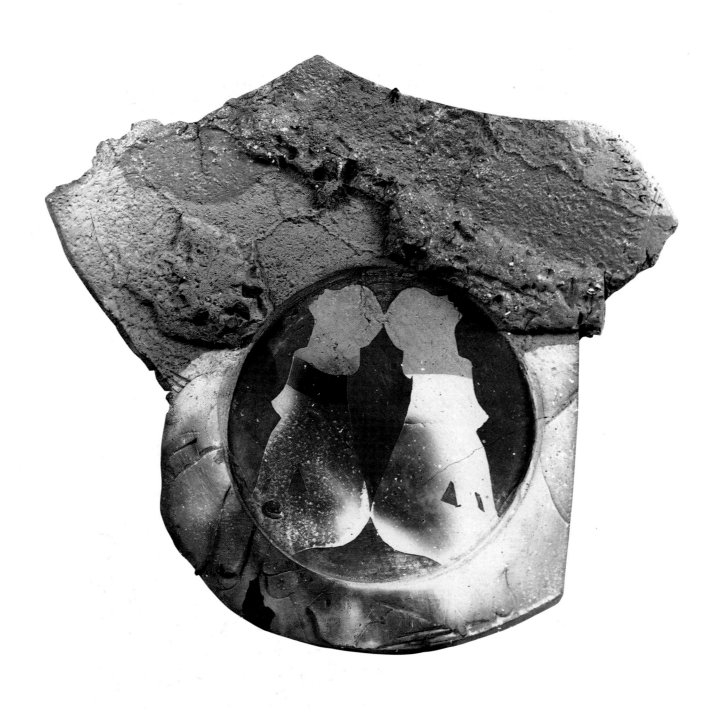

Wall Piece, 1979
CHECKLIST NO. 37

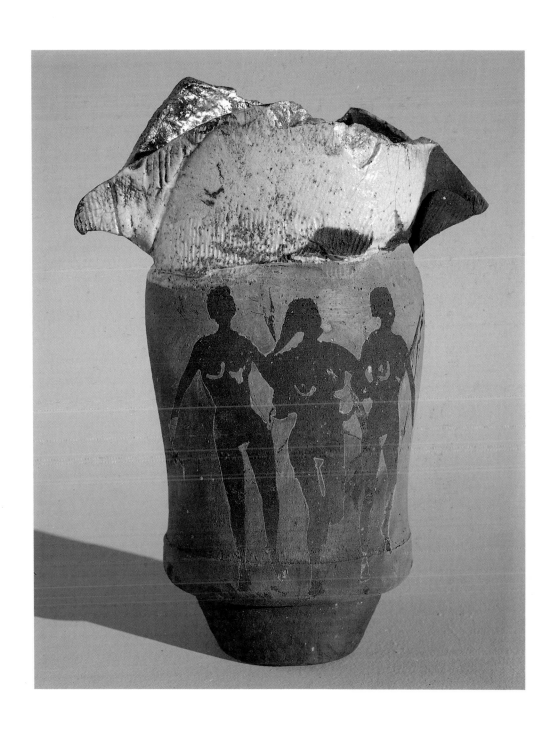

Vessel, c. 1980
CHECKLIST NO. 39

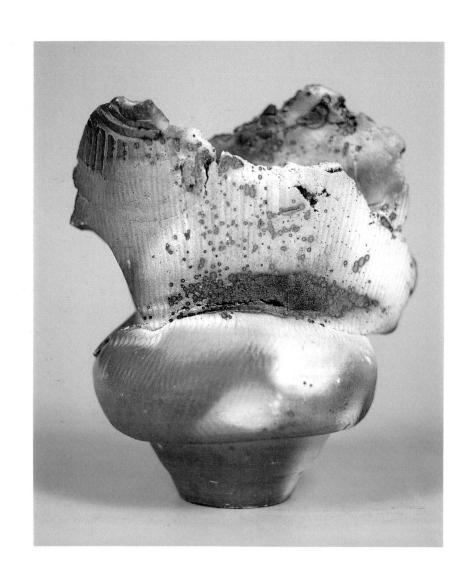

Pedestal Piece (82-63), 1982
CHECKLIST NO. 41

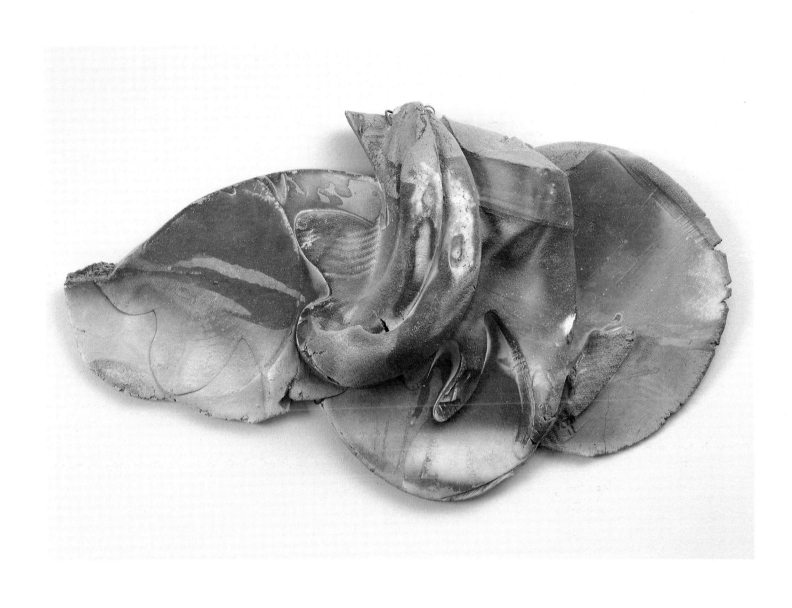

Wall Piece, 1982
CHECKLIST NO. 43

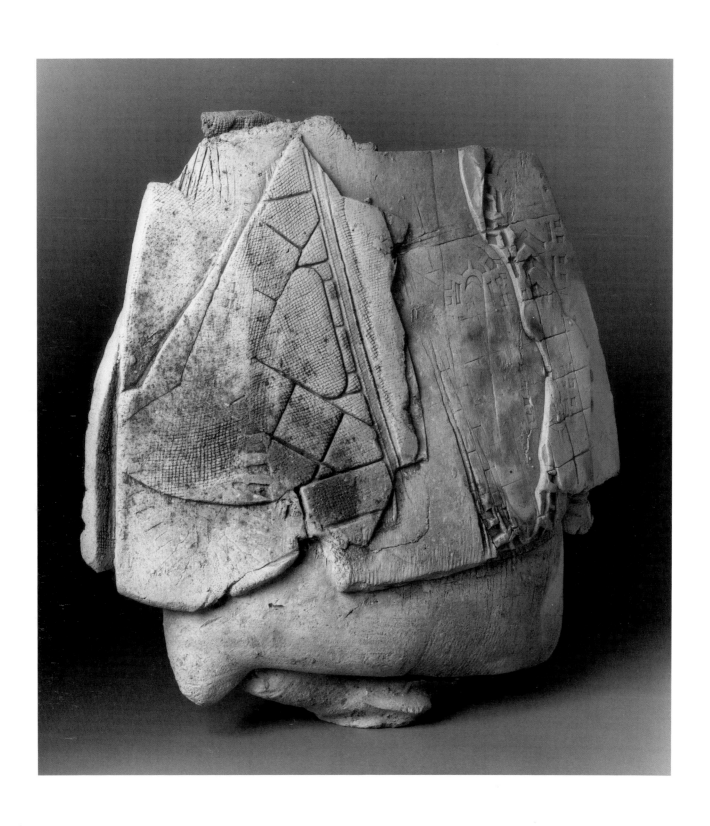

Pedestal Piece (82-121), 1982
CHECKLIST NO. 42

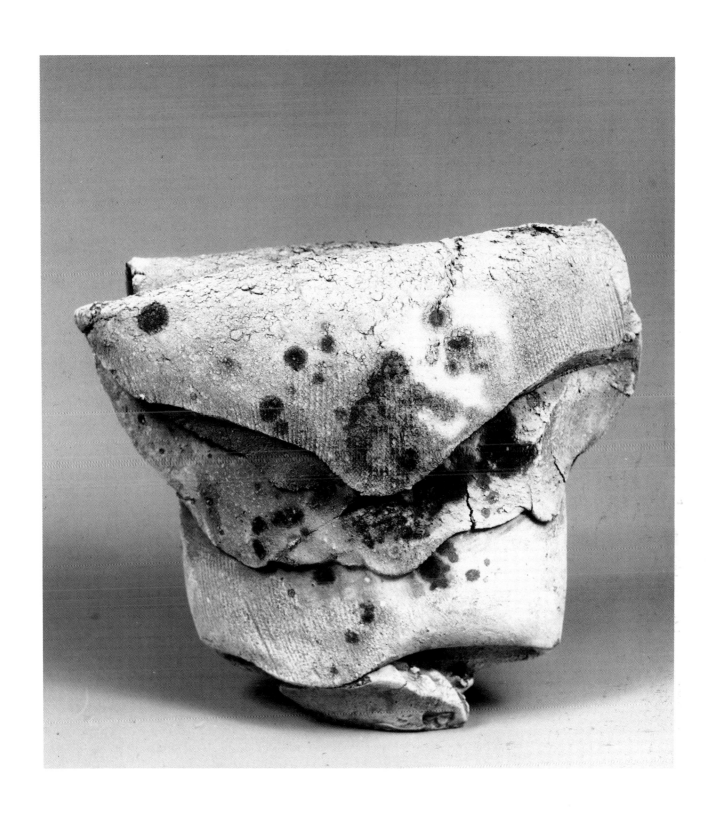

Pedestal Piece (83-16), 1983
CHECKLIST NO. 44

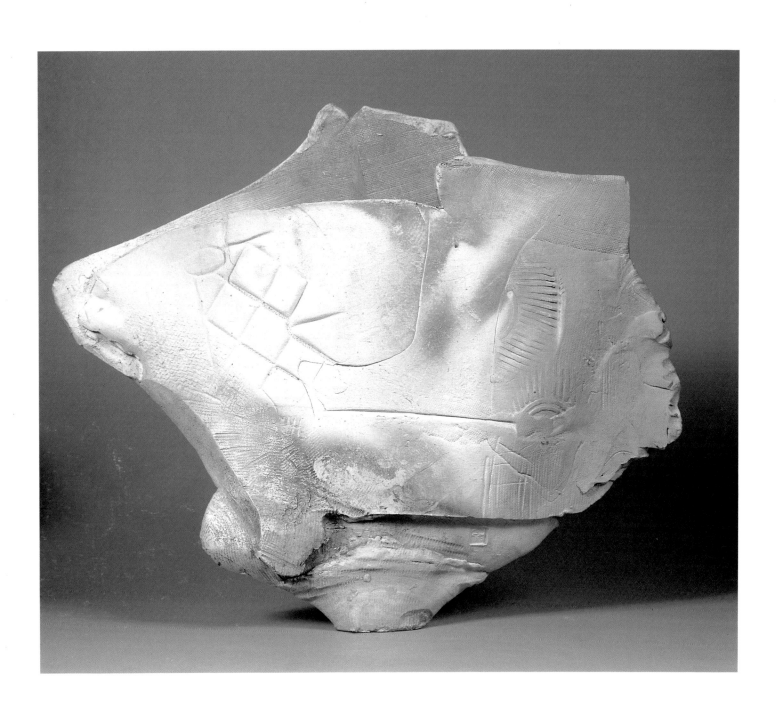

Pedestal Piece (83-28), 1983
CHECKLIST NO. 46

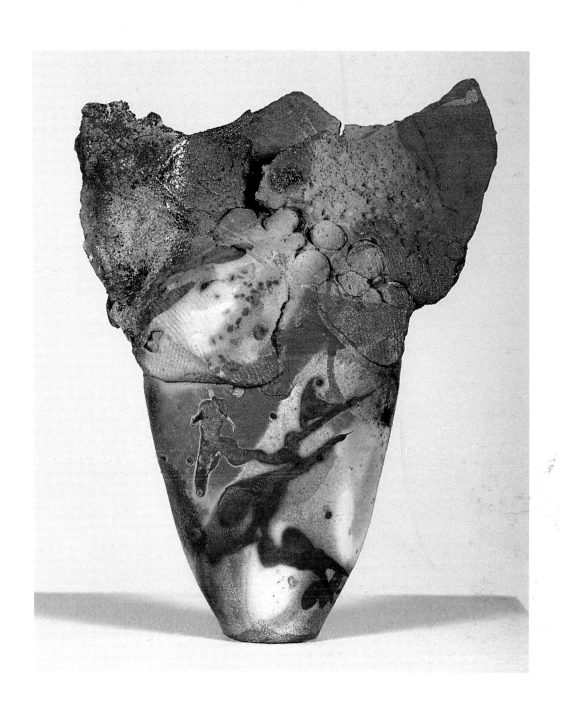

Pedestal Piece (84-28), 1984
CHECKLIST NO. 48

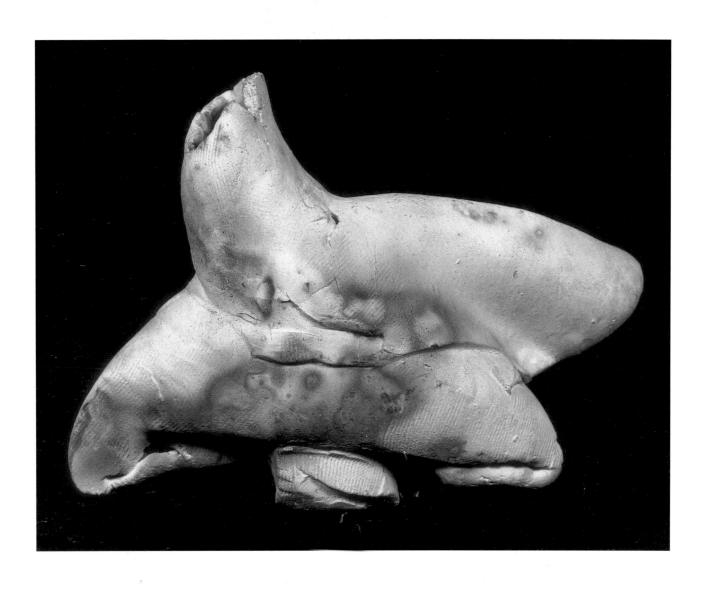

Pedestal Piece (83-19), 1983
CHECKLIST NO. 45

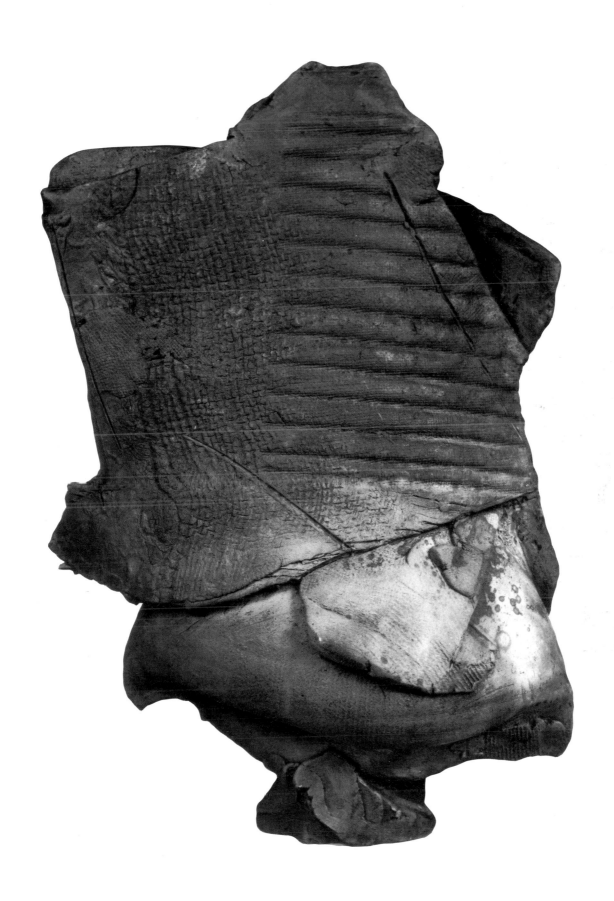

Pedestal Piece (84-49), 1984
CHECKLIST NO. 49

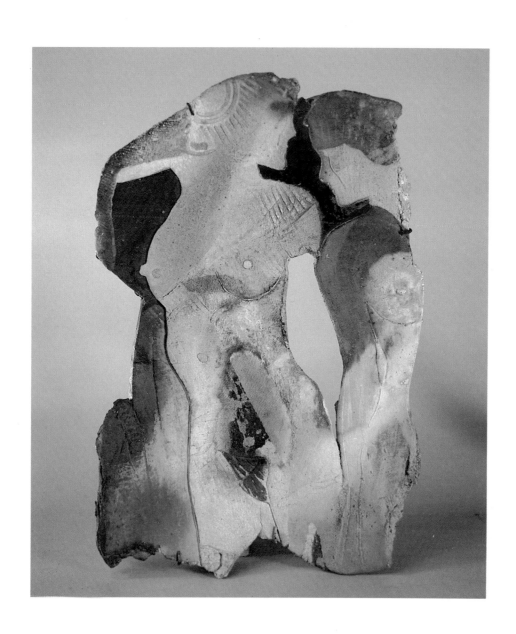

Wall Piece (84-68), 1984
CHECKLIST NO. 51

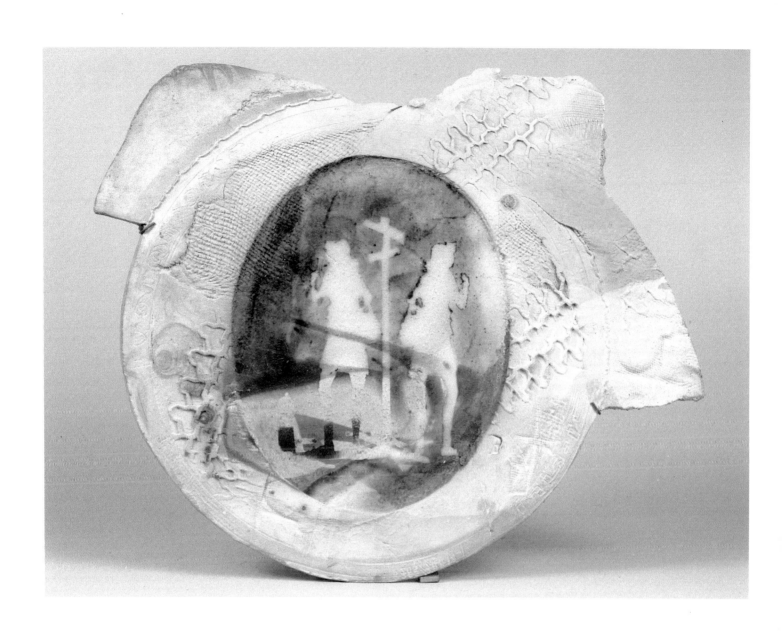

Wall Piece (85-6), 1985
CHECKLIST NO. 56

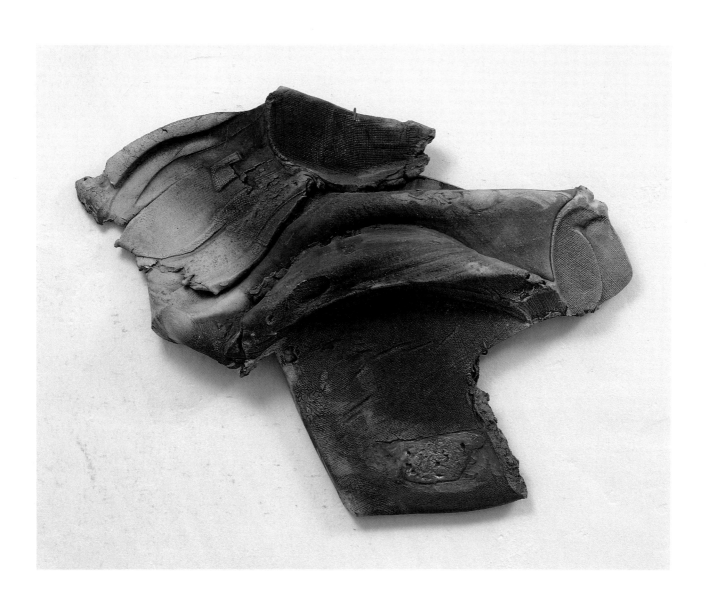

Wall Piece (84-66), 1984
CHECKLIST NO. 50

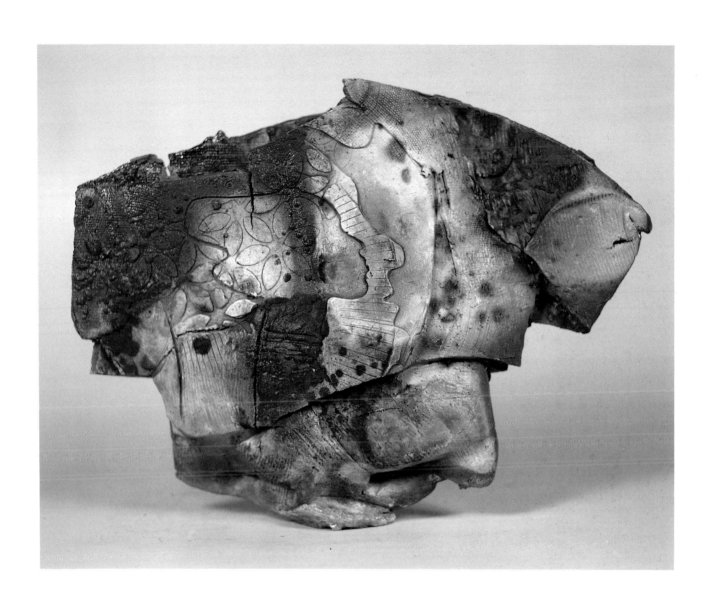

Pedestal Piece (84-69), 1984
CHECKLIST NO. 52

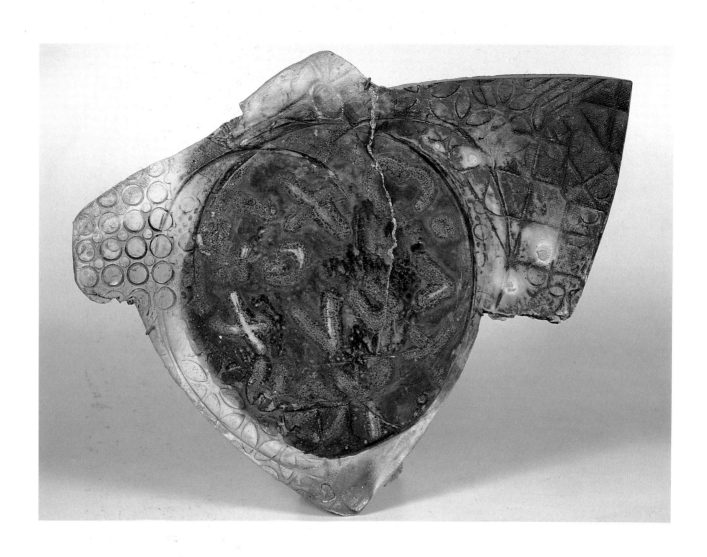

Wall Piece (Valentine) (85-29), 1985
CHECKLIST NO. 59

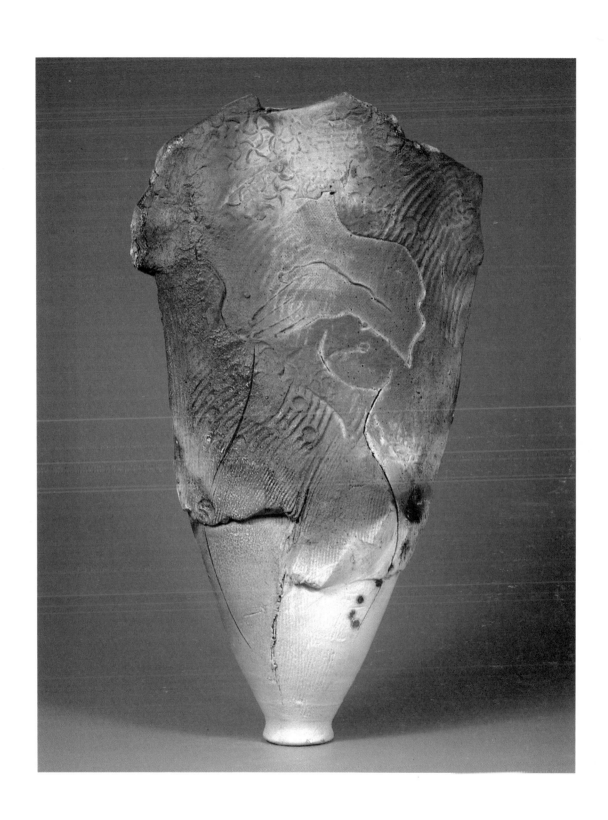

Pedestal Piece (85-38), **1985**
CHECKLIST NO. 60

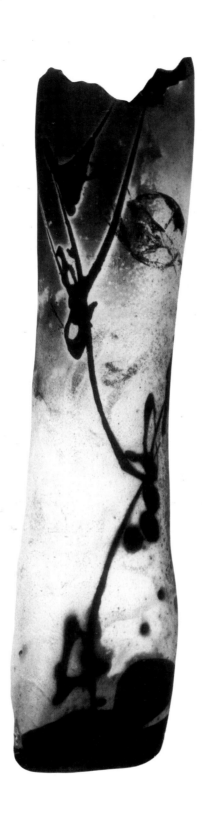

Vessel (84-82), 1984
CHECKLIST NO. 53

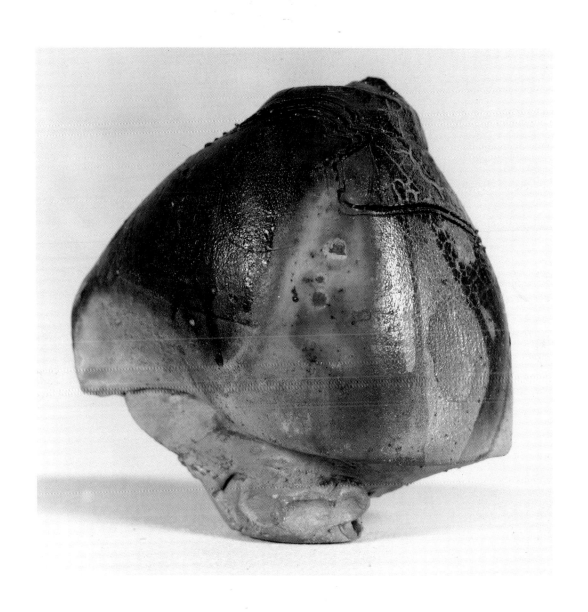

Pedestal Piece, 1984
CHECKLIST NO. 54

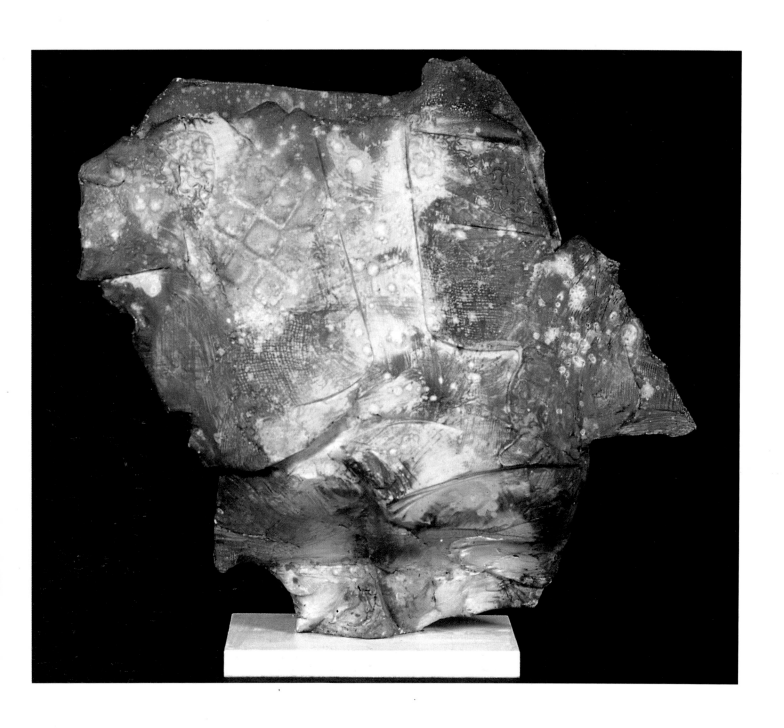

Pedestal Piece, **1985**
CHECKLIST NO. 61

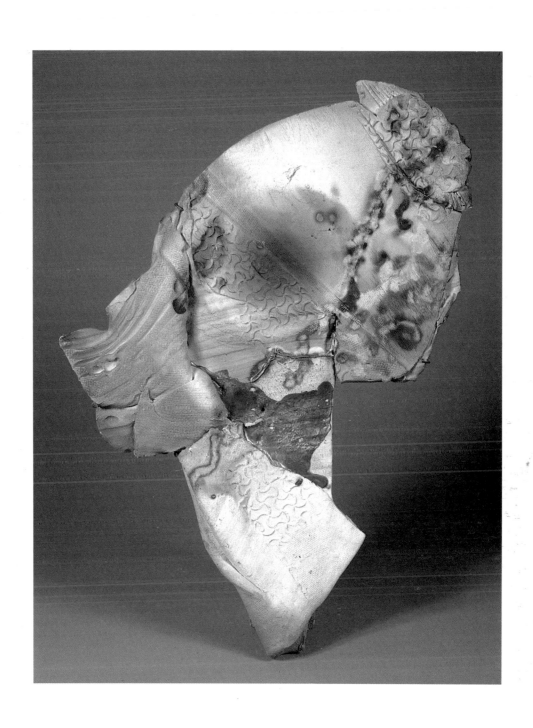

Wall Piece (86-14), c. 1986
CHECKLIST NO. 62

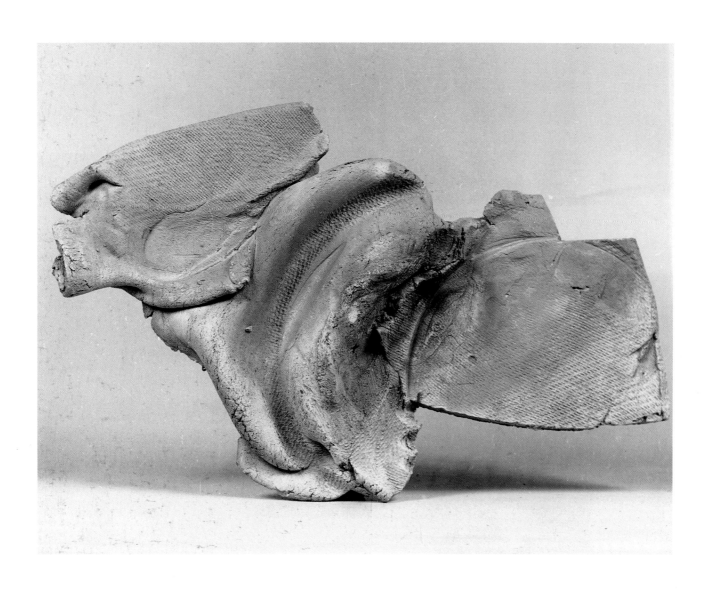

***Wall Piece*, 1984**
CHECKLIST NO. 55

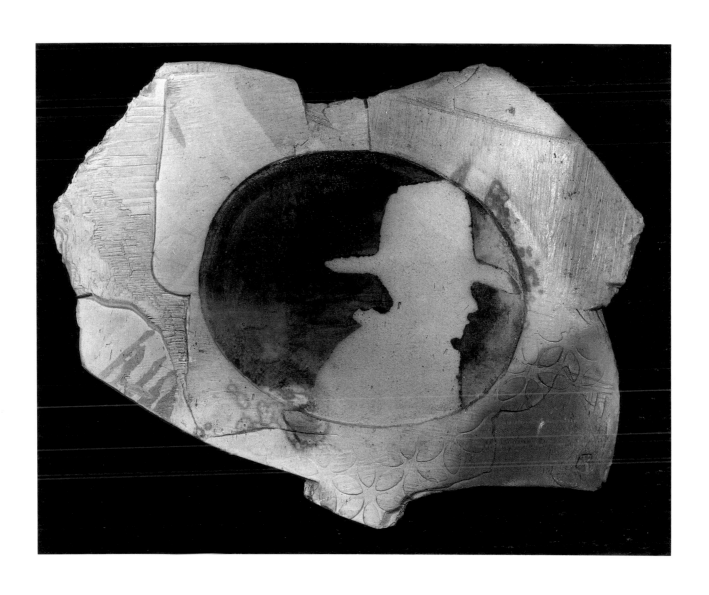

Wall Piece (Marlboro Man) (85-10), 1985
CHECKLIST NO. 57

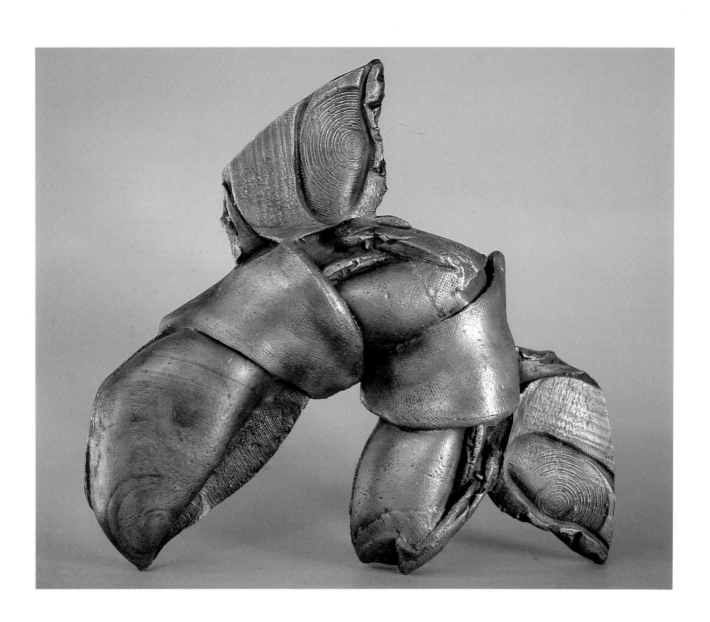

Wall Piece (86-38), 1986
CHECKLIST NO. 64

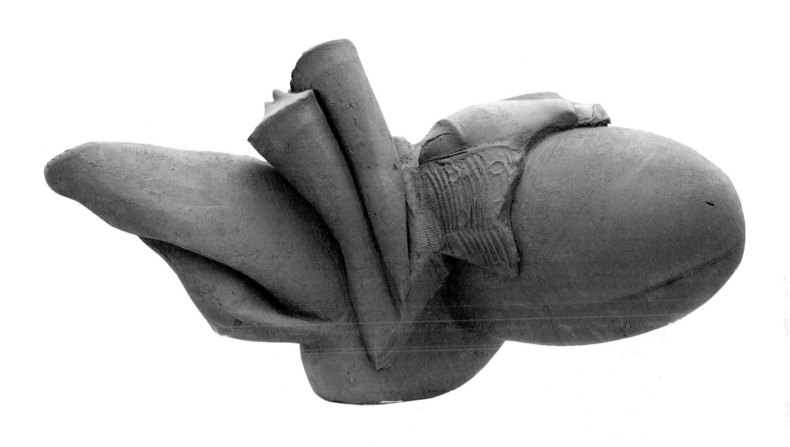

Pedestal Piece (87-7), 1987
CHECKLIST NO. 66

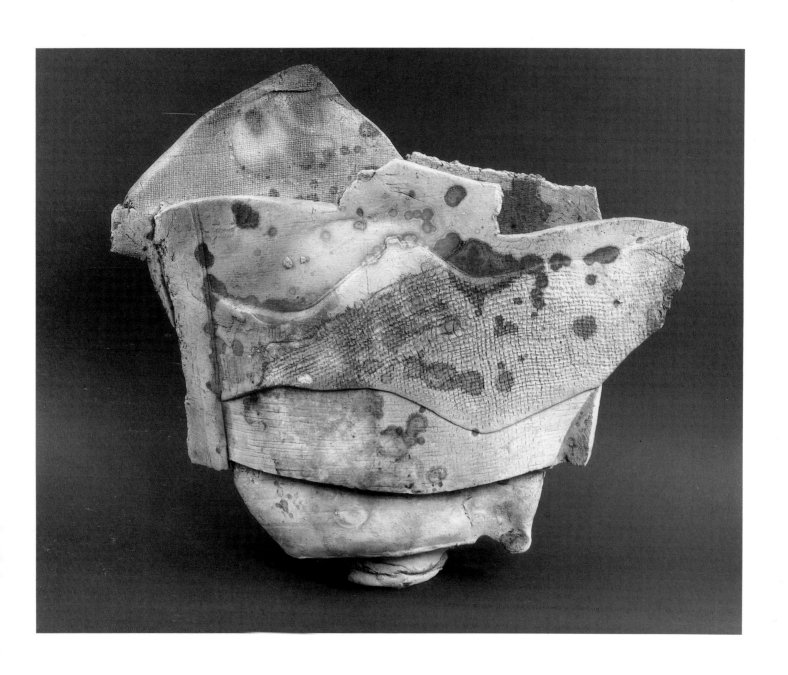

Pedestal Piece (85-15), 1985
CHECKLIST NO. 58

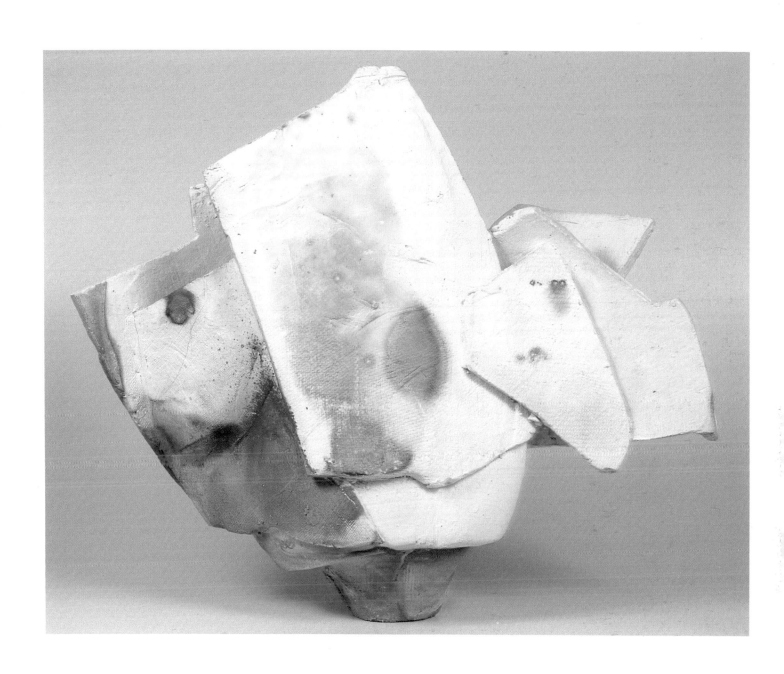

Pedestal Piece (87-12), 1987
CHECKLIST NO. 67

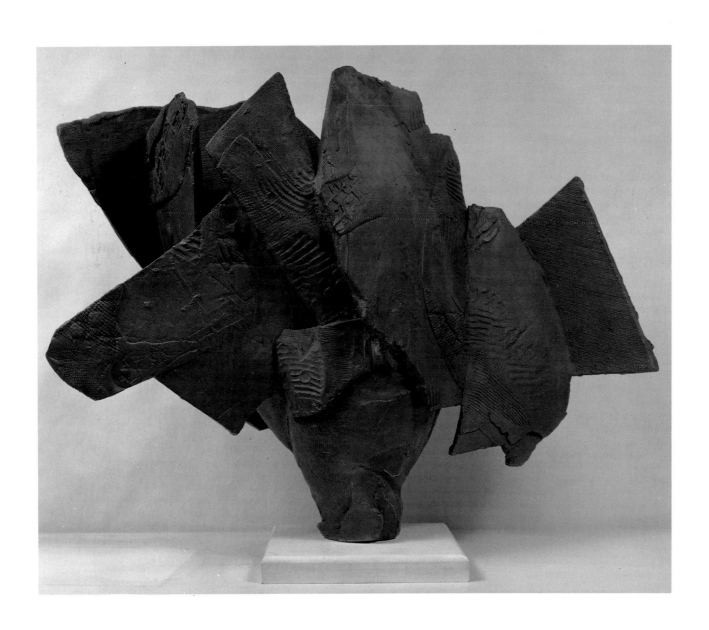

Pedestal Piece (87-6), 1987
CHECKLIST NO. 65

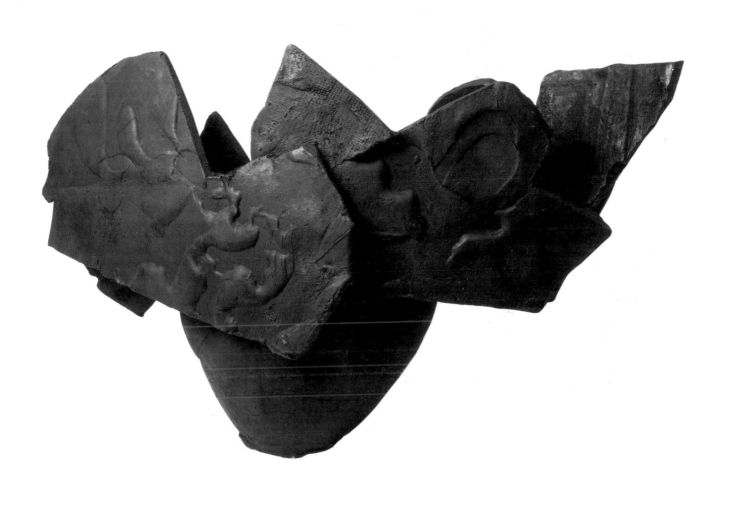

Pedestal Piece (87-15), 1987
CHECKLIST NO. 68

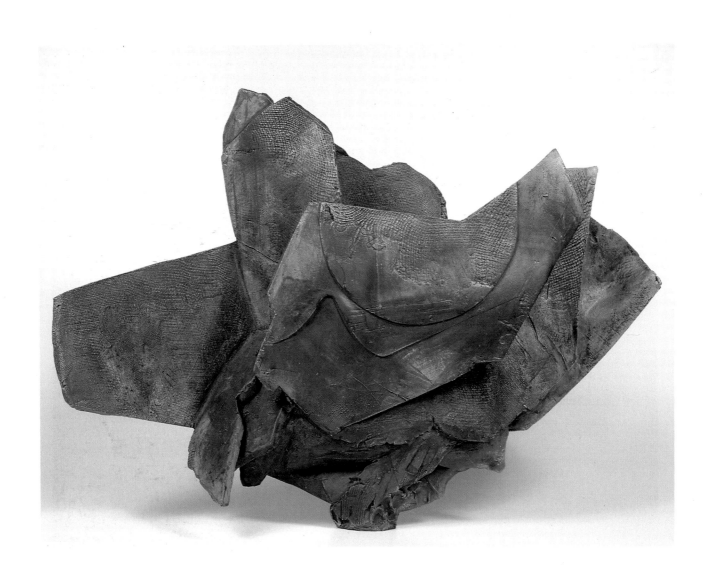

Pedestal Piece (88-24), 1988
CHECKLIST NO. 70

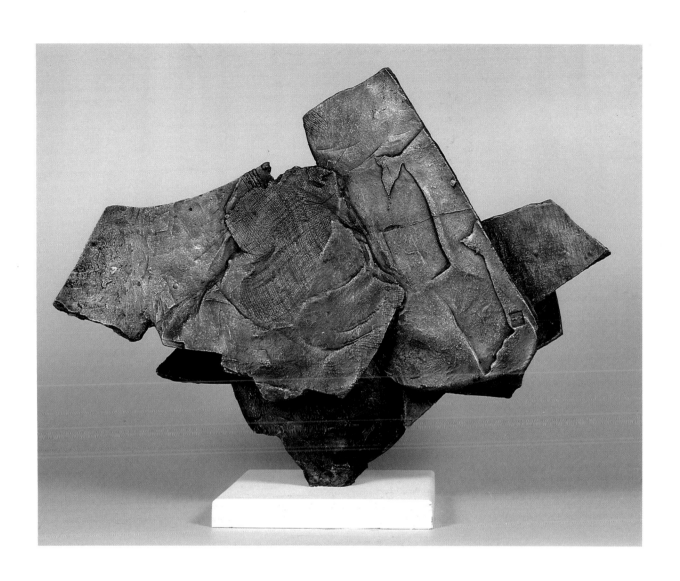

Pedestal Piece (89-10), 1989
CHECKLIST NO. 72

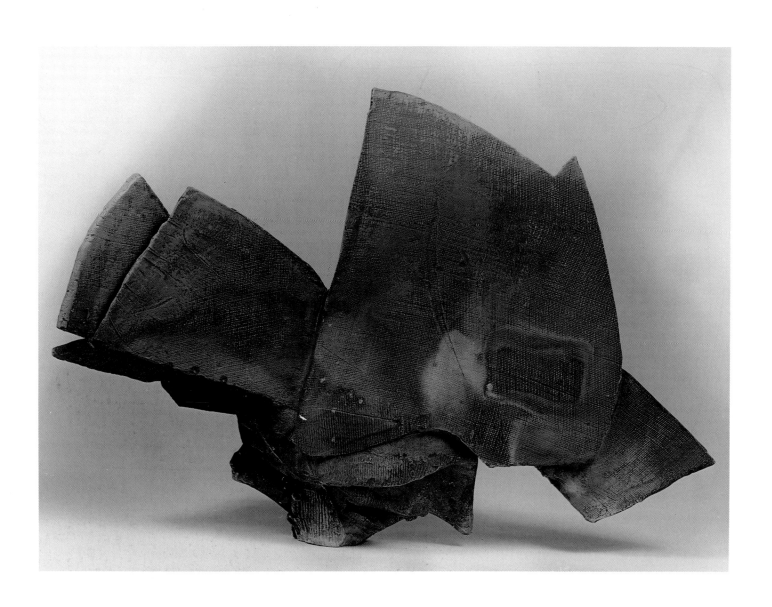

Pedestal Piece (88-7), 1988
CHECKLIST NO. 69

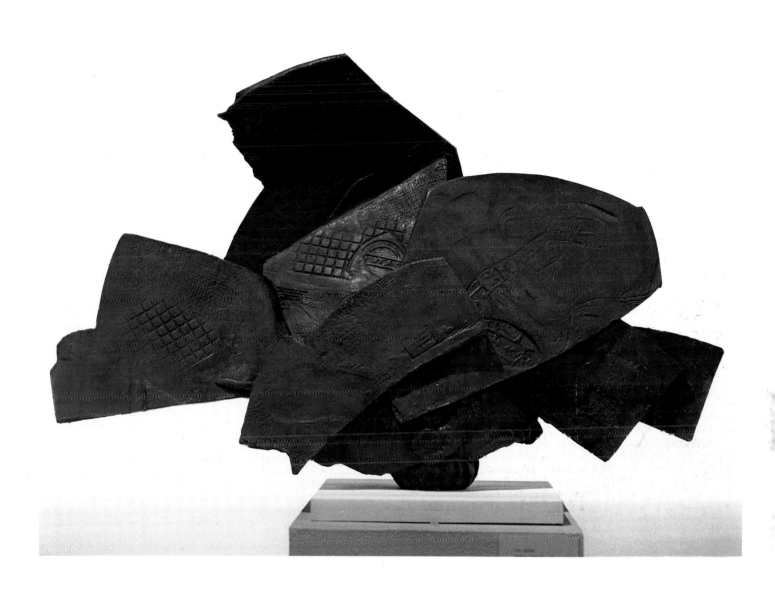

Pedestal Piece (89-7), 1989
CHECKLIST NO. 71

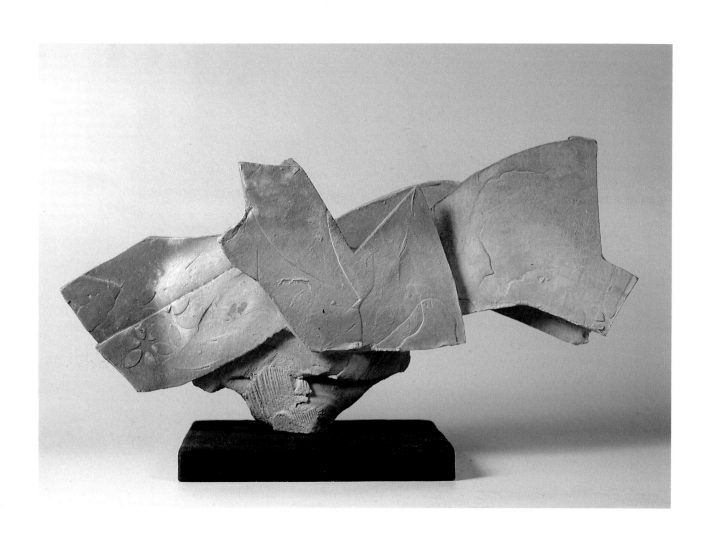

Pedestal Piece (90-12), 1990
CHECKLIST NO. 73

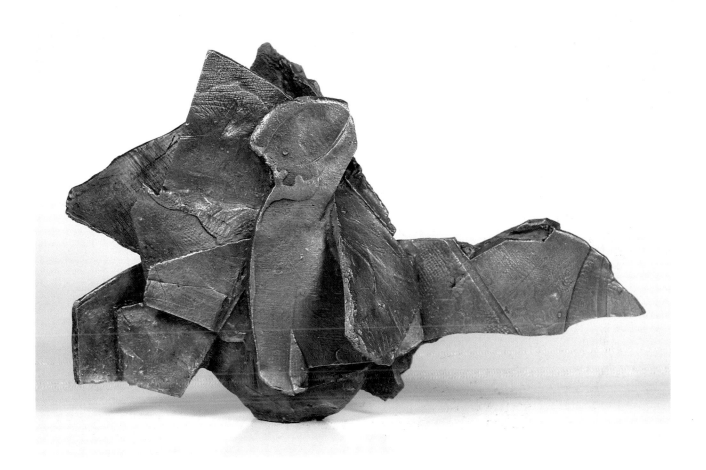

Pedestal Piece (90-13), 1990
CHECKLIST NO. 74

Selected Exhibition History

Special thanks go to the following individuals who provided information for this exhibition history: Ginny and Paul Soldner; Rick Hirsch, Professor of Ceramics, Rochester Institute of Technology, School of American Craftsmen; James P. May, Corporate Public Relations Manager, S.C. Johnson & Son, Inc.; Susan H. Myers, Curator, Division of Ceramics and Glass, National Museum of American History; Michael W. Munroe, Curator-in-charge, Renwick Gallery, Smithsonian Institution; April Oswald, Librarian, Everson Museum of Art; Eileen Rose, Associate Director for Programs, Smithsonian Institution Traveling Exhibition Service; and Linda Seckelson, Director of American Craft Information Center, American Craft Council.

An * indicates that a brochure or catalogue was published with the exhibition.

One-Person Exhibitions

1956 Los Angeles County Institute, Los Angeles
Ivory Tower Gallery, Los Angeles

1957 Mount St. Mary's College, Brentwood, Ca.

1961 Highlands University, Las Vegas
Craft Center, Santa Barbara

1963 Los Angeles State College, Los Angeles
New York University, Alfred, N.Y.
McPherson College, McPherson, Ks.

1964 *Raku Pottery: Paul Soldner*, Museum of
Contemporary Crafts, New York *

1966 The Egg and the Eye Gallery, Los Angeles
College of Wooster, Wooster, Oh.
The Signature Shop, Atlanta

1967 University of Colorado, Boulder
Pottery Northwest, Seattle
Craft House, Arroyo Seco, N.M.
Colorado State University, Ft. Collins
The Little Gallery, Kansas City, Kans.
State University of Iowa, Iowa City

1968 The Egg and the Eye Gallery, Los Angeles
L'atelier Galerie, Cedar Falls, Ia.
University Gallery, University of
Minnesota, Minneapolis
Archie Bray Foundation, Helena, Mt.
Coe College, Cedar Rapids, Ia.
Texas Tech College, Lubbock, Tx.
Sneeds Gallery, Rockford, Ill.

1969 University of Texas, Arlington
Cone 10 Gallery, Seattle
Birger Sandzen Memorial Gallery,
Lindsborg, Ks.
Bethany College, Lindsborg
Media Gallery, Orange, Ca.
Bethel College, Newton, Ks.
Arkansas Art Center Gallery, MacArthur
Park, Little Rock, Ar.
Museum of Art, University of Oklahoma,
Norman, Ok.
Murray State University Gallery,
Murray, Ks.

'70 Adams State College, Alamosa, Co.
Eastern Oregon College, La Grande, Or.
Galeria del Sol, Santa Barbara
The Brena Gallery, Denver
Fort Hays Kansas State College, Hays, Ks.
Allied Arts Society, The United States Air
Force Academy, Colorado Springs
Pot-Pourri Gallery, New York.
Patricia Moore Gallery, Aspen

1971 Eastern Texas State College, Dallas
Gima's Art Gallery, Honolulu
Contemporary Gallery, Dallas
Patricia Moore Gallery, Aspen
Media College, Orange, Ca.
The Potters Gallery, Sydney, Australia

1972 Arkansas Art Center Gallery, MacArthur
Park, Little Rock
Brena Gallery, Denver
Contemporary Gallery, Dallas
Talisman Gallery, Sante Fe
Galeria del Sol, Santa Barbara
Patricia Moore Gallery, Aspen
Gallerie 99, Bay Harbor Island, Fl.

1973 Manolides Gallery, Seattle
American Crafts Gallery, Cleveland
University Center Gallery, University of
Cincinnati, Cincinnati
Gallery 1309, Boulder
Craftsmen of Chelsea Court Gallery,
Kansas City, Mo.
Brena Gallery, Denver
Galerie 99, Bay Harbor Island

1974 Art Department Gallery, University of
Nebraska, Omaha
Patricia Moore Gallery, Aspen
Brena Gallery, Denver
Gallery 99, Bar Harbor
University Gallery, Colorado State
University, Fort Collins
Clay and Fiber Gallery, Taos

1975 Patricia Moore Gallery, Aspen
Florence Duhl Gallery, New York
Lodestone Gallery, Boulder
Elkhorn Depot Gallery, Sun Valley Center for

Arts and Humanities, Sun Valley, Idaho
Prairie House Gallery, Springfield, Il.
Birger Sandzen Memorial Gallery, Lindsborg, Ks.

1976 Contemporary Crafts Gallery, Portland, Or.
Pottery Northwest Gallery, Seattle
Sun Valley Center for the Arts and
Humanities, Sun Valley
Fine Arts Gallery, West Texas State
University, Canyon, Tx.
Kaplan-Bauman Gallery, Los Angeles
Fine Arts Gallery, University of Northern
Arizona, Flagstaff
Fine Arts Gallery, St. Paul Academy, St. Paul
Nostalgia Galleries, Stenson, Md.
Elements Gallery, Greenwich

1977 Pittsburgh Arts & Crafts Center, Pittsburgh
Sun Valley Center for the Arts and
Humanities, Sun Valley
The Hand and the Spirit Gallery, Scottsdale
Wexler/Weis Gallery, Encino, Ca.
Good Earth Gallery, Kansas City, Mo.
Patricia Moore Gallery, Aspen

1978 Gallery Nagoya, Nagoya, Japan
Renwick Gallery at the Smithsonian,
Washington, D.C.
Yaw Gallery, Birmingham, Mi.
Pacific Gallery, San Francisco, Ca.
Hills Gallery, Santa Fe
Contemporary Gallery, Dallas
Wichita Art Association, Inc., Wichita, Ks.
Grinshead Gallery, Central Missouri State,
Warrensburg, Mo.
Midland College, Midland, Tx.
Old Market Craftsmen Guild, Omaha

1979 Palm Gallery, San Diego
Elements Gallery, New York
Phoenix Gallery, Houston
Clay and Fiber Gallery, Taos
University Gallery, Louisiana State
University, Baton Rouge
Egner Fine Arts Center, Findlay, Oh.
Blue Sage Gallery, Kennewick, Wa.

1980 Elements Gallery, New York
Mandell Gallery, Los Angeles
Green Gallery, Carmel, Ca.
Winona State University, Winona, Mn.
Gallery Fair, Mendocino, Ca.
Wabash College, Crawfordsville, In.
Somerstown Gallery, Somers, N.Y.
Craftsmen's Gallery, Omaha
University of Southern Colorado, Pueblo
Sun Valley Center for the Arts and
Humanities, Sun Valley
Craft Alliance Gallery, Shreveport, La.

1981 Cantini Museum of Modern Art, Marseilles*
Marcia Rodell Gallery, Los Angeles
Yamato House, Lenox, Mass.

Patricia Moore Gallery, Aspen
Fresno Art Center, Fresno
1982 Galerie du Centre Genevois de L'Artisan,
Geneva, Switzerland
Hetjens Museum, Dusseldorf, Germany*
Elements Gallery, New York
Patricia Moore Gallery, Aspen
Utah State University, Logan
Taft College Art Center, Taft, Ca.
Objects Gallery, San Antonio
Anderson Ranch Art Foundation, Snowmass
Craft Alliance Gallery, St. Louis
Thomas Segal Gallery, Boston
1983 Elements Gallery, New York
Sebastian-Moore Gallery, Denver
Great American Gallery, Atlanta
Laguna Art Center, Laguna Beach, Ca.
Elmswood Gallery, Adelaide, Australia
Crafts Council of Tasmania, Hobart, Tasmania
Blackfriar Gallery, Sydney, Australia
Patricia Moore Gallery, Aspen
1984 Holsten Galleries, Palm Beach
Western Michigan University, Kalamazoo
Loyola University, New Orleans, La.
1985 Louis Newman Galleries, Beverly Hills *
Susan McLeaod Gallery, Sarasota, Fl.
University of California, San Diego
Maurine Littleton Gallery, Washington, D.C.
1986 Esther Saks Gallery, Chicago
Great American Gallery, Atlanta
Susan Cummins Gallery, Mill Valley, Ca.
College of the Redwoods, Eureka, Ca.
1987 University College of Wales, Aberystwyth, Wales*
Patricia Moore Gallery, Aspen
El Camino College Art Gallery, Torrance, Ca.
1988 Joan Hodgell Gallery, Sarasota, Fl.
San Angelo Art Center, San Angelo, Tx.
Esther Saks Gallery, Chicago
Goshen College Gallery, Goshen, In.
1989 Leah Ransburgh Art Gallery, University of
Indiana, Indianapolis
Southern Oregon State University Gallery,
Ashland, Or.
Tallin Exhibition Hall Gallery, Tallin, Estonia
1990 Louis Newman Galleries, Beverly Hills
Anderson Ranch Art Center Gallery, Snowmass
The Art Works Gallery, Riverside, Ca.
Manchester Craftsmen's Guild, Pittsburgh, Pa.
Marbeck Center, Bluffton College,
Bluffton, Oh.
1991 Fine Arts Gallery, Cypress College,
Cypress, Ca.
Paul Soldner: A Retrospective, Lang Gallery,
Scripps College, Claremont.* Traveled to:
1991 California College of Arts and Crafts,
Oakland
1992 Danforth Museum of Art,
Framingham, Ma.

Nora Eccles Harrison Museum of
Art, Utah State University, Logan
Huntsville Museum of Art,
Huntsville, Al.
Paine Art Center, Oshkosh, Wi.
1993 Lakeview Museum of Arts and
Sciences, Peoria, Il.
University Art Museum, Arizona State
University, Tempe, Az.
Fresno Art Museum, Fresno, Ca.
American Craft Museum, New York
Lowe Art Museum, University of
Miami, Coral Gables
1994 Aspen Art Museum, Aspen

Selected Group Exhibitions

1956 *12th Scripps College Invitational*, Lang Gallery,
Scripps College, Claremont
Craftsmanship in a Changing World, Museum of
Contemporary Crafts, New York
1957 *Group Exhibition*, Ferus Gallery, Los Angeles
13th Scripps College Invitational, Lang Gallery,
Scripps College, Claremont
Form and Fabric, Pasadena Art Museum,
Pasadena
5th Annual Miami National Exhibition, Lowe
Gallery, University of Miami, Coral Gables
1958 U.S.A. Pavilion, World's Fair, Brussels,
Belgium
6th Annual Miami National Exhibition, Lowe
Gallery, University of Miami, Coral Gables
1959 *Ostend International Exhibition*,
Ostend, Belgium
American Craftsmen Council Panel Exhibition,
American Craftsmen Council
Museum, New York
1960 *San Francisco Potter's Guild*, De Young
Museum, San Francisco
Craftsmen and Designers Show, Barnsdall
Gallery, Los Angeles
1961 *17th Scripps College Invitational*, Lang Gallery
Contemporary Craftsmen of the Far West,
Museum of Contemporary Crafts
1962 *Northwest Craftsmen*, Henry Gallery, Seattle
Ceramic International, Prague
Exhibition of Contemporary American Ceramics,
Arts and Industries Building,
Smithsonian Institution, National
Museum of History and Technology,
Washington, D.C.
1963 *19th Scripps College Invitational*, Lang Gallery
First Annual Ceramic Exhibition, San Jose
College, San Jose
1964 *United States Ceramics*, Art Museum,
Edmonton, Canada
*International Exhibition of Contemporary
Ceramics*, Tokyo
The Triennali, Venice, Italy
1965 *21st Scripps College Invitational*, Lang Gallery
Invitational California Design, Pasadena

Museum of Art, Pasadena
American Craftsmen, 1965, Krannert Art
Museum, University of Illinois,
Champaign
The Collector, Museum of Contemporary
Crafts, New York *
Tea Pot Exhibit, Museum of Contemporary
Crafts, New York *
13th Annual Miami National Exhibition, Lowe
Gallery, University of Miami, Coral
Gables
1966 *American Studio Potters*, Victoria and Albert
Museum, London *
American Craftsmen's Invitational, Henry Art
Gallery, University of Washington, Seattle
1967 *23rd Scripps College Invitational*, Lang Gallery
First Survey of Contemporary American Crafts,
University of Texas, Austin
1968 *Leading U.S. Object Makers*, Lee Nordness
Galleries, New York
25th Ceramic National Exhibition, Everson
Museum of Art, Syracuse, N.Y.
1969 *25th Scripps College Invitational*, Lang Gallery
50th Anniversary Exhibition, Otis Art Institute,
Los Angeles
*First National Invitational Exhibition of Ceramic
Art*, Nelson Gallery of Art, Kansas City Art
Institute, Kansas City, Mo.
Fine Arts Contemporary Gallery, Dallas Museum
of Art, Dallas
*Objects U.S.A.: Johnson Wax Collection of
Contemporary Crafts of the United States*,
Smithsonian Institution, National
Collection of Fine Arts, Washington,
D.C. * Traveled to:
1969 School of Fine and Applied Arts, Boston University,
Boston
1970 Memorial Art Gallery, University of
Rochester, Rochester, N.Y.
Galleries, Cranbrook Academy of Art,
Bloomfield Hills, Mi.
Indianapolis Museum of Art, Indianapolis
Cincinnati Art Museum, Cincinnati
St. Paul Art Center, St. Paul, Mn.
Museum of Art, University of Iowa,
Iowa City
Arkansas Art Center, Little Rock
Utah Museum of Fine Arts, Salt
Lake City
Seattle Art Museum, Seattle
Portland Art Museum, Portland, Or.
1971 Los Angeles Municipal Art Gallery
Oakland Art Museum, Oakland, Ca.
Phoenix Art Museum, Phoenix
Sheldon Memorial Art Gallery,
University of Nebraska, Lincoln
Milwaukee Art Center, Milwaukee
Chattanooga Art Association,
Chattanooga
Fort Worth Art Center Art Museum

Museum of Art, Carnegie Institute,
Pittsburgh
Columbia Museum of Art,
Columbia, S.C.
High Museum of Art, Atlanta
1972 Philadelphia Civic Center,
Philadelphia
Musée d'Art Moderne de la Ville, Paris
Museo Español de Arte
Contemporañeo, Madrid
1973 L'Umo et L'Arte, Milan
Kunstgewerbemuseum, Zurich
Museum fur Kunst und Gewerbe,
Hamburg
Liljevalchs Konstahall, Stockholm
1974 College of Art, Edinburgh City
Museum and Art Gallery, Birmingham
Palais des Beaux-Arts, Brussels
1970 Ceramics 70, Everson Museum of Art,
Syracuse, N.Y.
Ceramics Invitational, Fort Wayne Museum of
Art, Fort Wayne, Ind.
Art in Other Media, Burpee Art Museum,
Rockford, Il.
1971 Ceramics '71 Plus Woven Forms, Everson
Museum of Art, Syracuse, N.Y.
Contemporary Ceramic Art: Canada, U.S.A.,
Mexico, and Japan, The National
Museum of Modern Art, Kyoto *
1972 Annual Ceramics West Exhibition, Nora Eccles
Harrison Museum of Art, Utah State
University, Logan
Major Ceramists of the United States, Northern
Arizona University Art Gallery,
Northern Arizona University, Flagstaff
Idaho State University, Pocatello
The Collection of Dr. and Mrs. R. Joseph
Monsen, San Francisco Museum of Art *
International Ceramics, Victoria and Albert
Museum, London *
1973 Contemporary Ceramics I, University Art
Museum, University of California,
Santa Barbara
California Crafts VIII, Crocker Art Museum,
Sacramento
The Sea of Japan Exposition, Kanazawa,
Ishikawa, Japan
Ceramic National, John Michael Kohler Arts
Center, Sheboygan, Wi.
International Exhibition of Ceramics from the
Victoria and Albert Museum, Victoria and
Albert Museum, London.*
1974 Second Chunichi International Exhibition of
Ceramic Art, Nagoya, Japan *
Objects: Invitational Exhibition, California State
University Gallery, California State
University, San Bernardino
National Exhibition of Salt and Raku Ceramics,
National Council on Education for the
Ceramic Arts, Madison, Wi., and N.Y.

In Praise of Hands, World Craft Conference
Exhibition, Toronto, Canada
1975 Masters in Ceramic Art, Everson Museum of
Art, Syracuse, N. Y.*
First Annual Ceramics Invitational, California
Institute of the Arts, Valencia
Two Hundred Years of Ceramic Art, Temple
University School of Art,
Philadelphia
Colorado Celebration of the Arts, Natural
History Museum, Denver
1976 National Ceramic Invitational, Moreau Gallery,
St. Mary's College, Notre Dame, In.
Fourth Clay Invitational, Edinboro State
College, Edinboro, Pa.
1977 Fellows of the American Craft Council, Wake
Forest University, Winston-Salem, N.C.
Foundations in Clay, Los Angeles Institute of
Contemporary Art, Los Angeles
Seven Artists in Clay, National Council on
Education for the Ceramic Arts,
Greeley, Co.
Raku, Elements Gallery, Greenwich
Twelve Nationally Known Ceramic Artists,
Chadron State College, Chadron, Ne.
Claremont Colleges Art Faculty Exhibition, Lang
Gallery *
Clay II, Riverside Art Center & Museum,
Riverside, Ca.
The Philadelphia Craft Show, Philadelphia
Museum of Art, Philadelphia
Claremont Potters, Griswold's Art Gallery,
Claremont
Colorado Artist/Craftsmen, Fine Arts Museum,
Aurora, Co.
1978 Non-Functional Ceramics, Imabashi Gallery,
Figimoni Building, Osaka
Colorado Crafts: 17 Views, Denver Art
Museum, Denver
1979 American Ceramics, Helen Drutt Gallery,
Philadelphia
Impressions in Clay: Outstanding American
Ceramicists, Impressions Gallery, Boston
A Century of Ceramics in the United States, 1
878-1978, Everson Museum of Art,
Syracuse, N.Y.* Traveled to:
1980 Renwick Gallery of the National
Collection of Fine Arts, Smithsonian
Institution, Washington, D.C.
Raku and Primitive Firing Technique, Art
Gallery, William and Mary College,
Williamsburg, Va.
National Ceramic Exhibition, The Museum of
Ceramic Art, Baltimore *
Art Faculty Exhibition of the Claremont Colleges,
Lang Gallery *
Current Concepts in Clay, Sangre de Cristo Arts
and Conference Center, Pueblo, Colo.
1980 1980 Chunichi International Ceramic Arts
Exhibition, Nagoya, Japan *
Collector's Clay, Cooper-Hewitt Museum,
New York

VII Biennale Internationale de Céramique d'Art
de Vallauris, Vallauris, France
Plate Show, Everson Museum of Art,
Syracuse, N.Y. *
Ceramic Traditions, University of Oregon, Eugene
Ceramics Invitational 1980, University of
Wisconsin, Menomonie, Wi.
1981 Paul Soldner and Five European Ceramists Who
Worked With Him, Centre Genevois de
l'Artisan, Geneva, Switzerland
Clay Roots/Routes, Cooper Lynn Gallery,
New York
American Potters I, Hadler/Rodriquez Galleries,
New York
Made in L.A., Art Gallery, Federal Reserve Board
Building, Washington, D.C. *
Colorado Artists in the National Capitol, Seraph
Gallery, Washington, D.C.
Los Angeles Bicentennial Exhibition of
Contemporary Crafts, Craft and Folk Art
Museum, Los Angeles, *
L'Affair du Coeur, Sylvia Ullman Gallery,
Cleveland, Oh.
Fifth National Crafts Invitational, Schick Art
Gallery, Skidmore College, Saratoga
Springs, N.Y.*
Ceramic Traditions, Smithsonian Institution
Traveling Exhibitions, Washington, D.C.
* Traveled to:
1980 University of Wyoming, Laramie
University of Montana, Missoula
West Montana College, Dillon Arts
Chateau, Butte, Mt.
Lewistown Art Center, Lewistown, Mt.
Custer County Art Center, Miles City, Mt.
University of Oregon, Eugene
1982 Pacific Currents/Ceramics 1982, San Jose Museum
of Art, San Jose
American Clay Invitational, Meredith
Contemporary Art, Washington, D.C.
Raku Internationale, Galerie le Labyrinthe,
Uzes, France
Conference Exhibition, National Council on
Education for the Ceramic Arts, Mills
College, Oakland, Ca.
Art Faculty Exhibition of the Claremont Colleges,
Lang Gallery *
National Clay Show: 20 Artists, Monterey
Peninsula of Art, Monterey, Ca.
The Contemporary American Potter, Smithsonian
Institution Traveling Exhibition Service,
Washington, D.C. * Traveled to:
1982 Contemporary Arts Center, Kansas
City, Mo.
Colorado Gallery of the Arts, Littleton
Visual Arts Center of Alaska, Anchorage
Huntsville Museum of Art, Huntsville, Al.
Art Museum of South Texas, Corpus
Christi

Leigh Yawkey Woodson Art Museum, Wausau, Wi.

1983 *American Clay Artists*, The Clay Studio, Philadelphia*

A Personal View: Selections from the Joan Mannheimer Ceramic Collection, Gallery of Art, University of Missouri, Kansas City *

Echoes: Historical References in Contemporary Ceramics, Nelson-Atkins Gallery of Art, Kansas City, Mo.

California Clay in the Rockies, Anderson Ranch Art Gallery, Snowmass

1984 *Earth and Fire: The Marer Collection of Contemporary Ceramics*, Montgomery Gallery, Pomona College, Claremont *

Plates and Platters, University Gallery, Boston College, Newton, Mass.

Clay: 1984, A National Survey Exhibition, Traver Sutton Gallery, Seattle

International Academy of Ceramics Invitational, North Central Washington Museum, Wenatchee*

Raku and Smoke, The Newport Art Museum, Newport, R.I. * Traveled to: American Craft Museum, New York

Clay Vessels, Palo Alto Cultural Center, Palo Alto, Ca.

Masterworks, Louis Newman Gallery, Beverly Hills *

Art in Clay: Evolution, Revolution, Continuation, Municipal Art Gallery, Los Angeles *

Masters in American Clay, Gallery One, Toronto

1985 *Claremont Influences: A Clay Show*, Susan Cummins Gallery, Mill Valley, Ca.

Clay: Beyond Function, Colorado Gallery of the Arts, Littleton

The Creative Spirit: A Celebration of Contemporary American Craft, Maier Museum of Art, Lynchburg, Va. *

Clay, Dayton Art Institute, Dayton

Surface/Function/Shape, Southern Illinois University, Edwardsville*

Santa Monica Clay Invitational, Art Gallery, Santa Monica College, Santa Monica

"Ceramic Works from the Everson Museum of Art," shown at the *13th Chunichi International Exhibition of Ceramic Arts*, Chunichi Building, Nagoya, Japan *

1985 International Ceramics Exhibition, Taipei Fine Arts Museum, Taipei, Taiwan *

Ceramic Invitational, Lawrence Gallery, Portland, Or.

Raku, Images Gallery, Sun Valley

Critics Choice, Sun Valley Center for the Arts and Humanities, Sun Valley

Scripps College Faculty Exhibition, Lang Gallery

1986 *International Ceramics '86*, Mino, Japan

American Potters Today, Victoria and Albert Museum, London *

Craft Today: Poetry of the Physical, American Craft Museum, New York * Traveled to:

1987 Phoenix Art Museum, Phoenix
Laguna Art Museum, Laguna Beach
Denver Art Museum, Denver

1988 Milwaukee Art Museum, Milwaukee
Virginia Museum of Fine Arts, Richmond
J. B. Speed Art Museum, Louisville, Ky.

Ceramic Invitational, Palo Alto Cultural Center, Palo Alto

The Carroll and Hiroko Hansen Collection of Ceramic Art, Arvada Center for the Arts and Humanities, Arvada, Co.

1987 *American Ceramics Now*, Everson Museum of Art, Syracuse. * Traveled to:

1988 American Craft Museum, New York

1989 De Cordova and Dana Museum, Lincoln, Ma.
Butler Institute of Art, Youngstown, Oh
Birmingham Museum of Art, Birmingham, Al.

Selections from the Smits's Collection of 20th Century Ceramics, Los Angeles County Museum of Art*

The Eloquent Object, Philbrook Museum of Art, Tulsa, Ok. * Traveled to:

1988 Oakland Museum, Oakland
Museum of Fine Arts, Boston
Chicago Public Library Cultural Center, Chicago

1989 Orlando Museum of Art, Orlando
Virginia Museum of Fine Arts, Richmond
Kyoto National Museum of Modern Art, Kyoto

1990 Yomiyuri Shinbun, Tokyo

Maloof, McIntosh and Soldner, Clark Humanities Museum, Scripps College, Claremont

25 Years: An Anniversary Exhibition, Creative Arts Workshop Gallery, New Haven

The Living Desert 5th Annual Art Invitational, Living Desert Art Gallery, Palm Desert

Scripps College Faculty Exhibition, Lang Gallery

Claremont Artists, 1930-1980, Art Gallery, Claremont Graduate School, Claremont

1988 *Ceramic Sculpture: Sources and Statements*, Munson Gallery, Santa Fe

Ceramic Forms, Craftsmen's Potters' Shop,

William Blake House, London

East Meets West, Contemporary Crafts Gallery, Portland, Or.

MOA International Ceramics Exhibition, MOA Foundation Gallery, Los Angeles

Colorado Invites: National Exhibition, Sangre de Cristo Arts and Conference Center, Pueblo, Co.

New Art Forms, Navy Pier Building, Chicago

1989 *Mirror Images: Reflections in Clay*, Craft Alliance Gallery, St. Louis

Clay AZ Art XV: International Ceramics Conference Exhibition, Art Gallery, Northern Arizona University, Flagstaff

Fragile Blossoms: Enduring Earth: The Japanese Influence on American Ceramics, Everson Museum of Art, Syracuse, N.Y. * Traveled to:

1990 American Craft Museum, New York

Raku: Transforming the Tradition, sponsored by the National Council on Education for the Ceramic Arts, Kansas City Contemporary Arts Center, Kansas City, Mo. * Traveled to:

1989 School for American Craftsmen, Rochester Institute of Technology, Rochester, N.Y.

1990 *Scripps College Faculty Exhibition*, Lang Gallery*

New Art Forms: Chicago International Exposition, Navy Pier Building, Chicago

Ten from Bluffton: Ceramics by Bluffton College Alumni, Art Gallery, University of Cincinnati, Cincinnati

Art at Scripps: An Inaugural Celebration, Lang Gallery *

1991 *Beyond Serving: Clay Platters*, Moira James Gallery, Green Valley, Nv.

Souvenirs/Postcards International: Clay as Document, Dialogue and Humorous Exchange, Potters Gallery, Brisbane, Queensland, Australia

Cosmos within Hands: Tea Bowl Exhibition, Tom Gallery, Tokyo, Japan*

Thirty Ceramic Sculptors, Natsoulas Novelozo Gallery, Davis, Ca.

Selected Bibliography

The bibliography is divided into the following sections: articles and statements by the artist; interviews with the artist; films and videotapes; articles; and books. Items are arranged alphabetically except where otherwise noted.

A. Articles and Statements by Paul Soldner
(arranged chronologically)

Soldner, Paul. "The Experimental Craftsman." *Craft Horizons* 23 (1963).

———. "Raku." Exhibition brochure. New York: American Crafts Council, 1964.

———. "A Kiln Is Built." *Craft Horizons* 25 (January 1964): 38–39.

———. "Paradoxes of the Creative Potter." *Pottery in Australia*, 1966.

———. "Workshop with Paul Soldner: Firing with Oil." *Craft Horizons* 28 (January 1968): 16–19.

———. "Raku as I know it." *Ceramic Review* 9 (July-August 1973).

———. "Energy." *Studio Potter* 3 (Summer 1974): 34.

———. "Oil-burning kilns." *Studio Potter* 3 (Summer 1974): 49.

———. "Analyzing Electric Wheels." *Studio Potter* 3 (Winter 1974): 21–24.

———. "The Anti-Establishment Clay Mixer." *Studio Potter* 4 (Winter 1976): 24–25.

———. "Scripps Invitational." *Ceramics Monthly* 31 (February 1983): 60–61.

———. "Creative Limbo." *Studio Potter* 12 (June 1984): 23–24.

———. "Drawing on Clay, The Personal Mark." *Studio Potter* 14 (December 1985): 62–64.

———. "The American Way of Raku." *Ceramic Review* 124 (July-August 1990): 8–11.

Soldner, Paul, and James Melchert. "Fred Marer and the Clay People." *Craft Horizons* 34 (June 1974): 38–48.

B. Interviews with Paul Soldner

Huffman, Mark. "Paul Soldner: An Interview with a Founder of the Anderson Ranch." *Aspen Times*, June 14, section C, p. 1.

Levin, Elaine. "Vessels of Celebration." Oral History Program, Department of Special Collections, University Research Library, University of California, Los Angeles. Unpublished typescript. Sept. 3 and 4, 1980.

McKinnell, Nan, and Jim McKinnell. "Biscuit Firing, Advice from Paul Soldner." *Studio Potter* 15 (December 1986):40–43.

Ransom, Connie, "Renaissance Man: An Interview with Paul Soldner." *Elan* (November 1990): 58–59.

C. Films and Videotapes *(arranged chronologically)*

Earth and Fire. New York: Summit Films, Image Resources Film Library, 1970.

With These Hands. From *The Rebirth of the American Craftsman.* Los Angeles: ABC Television, 1970.

Ceramics: Paul Soldner. Los Angeles: TV Campus Profile Series, 1971.

A Potter's Song: The Art and Philosophy of Paul Soldner. Aspen: Crystal Productions, 1974.

Paul Soldner: Potter. From *Expressions TV Series*, Denver: Channel 6, 1975.

Paul Soldner: Thoughts on Creativity. Los Angeles: The American Ceramic Society, 1989.

The World of Paul Soldner. Pittsburgh: WQED Communications, 1990.

D. Articles on Paul Soldner

"Aller/retour pour la côte ouest." *Céramique* 69 (June-July, 1982): 10–13.

"Anderson Ranch Arts Center Honors Soldner Next Week." *Aspen Times*, June 14, 1990, p. C2.

Berman, Rick. "A Modern Master: Paul Soldner." *Art Papers* 7 (March-April 1983).

Biagini, Jean. "Paul Soldner." *L'atelier des métiers d'art* 62 (1978).

Brumfield, John. "Southern California Clay." *Artweek* 15 (11 August 1984): 5.

Burstein, Joanne. "Paul Soldner." *American Ceramics* 1 (Spring 1982): 46–47.

"Ceramic Shows Demonstrate State of Art." *Claremont Courier* (7 March 1984).

Clifford, Peggy. "The Wizard of Raku." *Aspen Times* (8 December 1977).

Dunham, Judith. "Paul Soldner." *American Craft* 42 (October-November 1982): 24–28.

Fox, Catherine. "Soldner Ceramics Reflect the Oriental and Accidental." *The Atlanta Newspaper* (January 1983).

Fudge, Jane. "Under the Influence." *Artweek* 20 (April 1988): 4.

Grand, Paule-Marie. "Céramiques à tout casser." *Le Monde* (December 1981).

Jepson, Barbara. "American Ceramists." *Town and Country* 35 (May 1981): 205–208.

Knight, Christopher. "Los Angeles, Art on the Move." *Art News* 82 (January 1983): 72–79.

———. "Otis Clay: A Revolution in the Tradition of Pottery." *Los Angeles Herald Examiner* (29 September 1982).

Kuspit, Donald B. "Elemental Realities." *Art in America* 69 (January 1981): 78–87.

Levin, Elaine. "Paul Soldner: Portfolio." *Ceramics Monthly* 27 (June 1979): 59–70.

Lieberman, Laura C. "High Museum's Craft Exhibition." *Journal-Constitution*, Atlanta, Ga. (3 January 1989).

Malarcher, Patricia. "Dealing with the World of Reality." *New York Times* (19 June 1984).

Maloney, Ann. "Artist Molds New Approach to Raku." *The Maroon*, Loyola University (30 March 1984).

McCloud, Mac. "The Scripps Influence." *Ceramics Monthly* 37 (November 1989): 51.

Muchnic, Suzanne. "Championing Clay as Fine Art." *Los Angeles Times* (21 July 1984).

———. "Two Unbroken Ceramic Traditions." *Los Angeles Times* (13 March 1984).

"One of the World's Best in Ceramics Here Today." Adelaide *Newspaper*, Adelaide, Australia (May 1983).

"Outstanding Contemporary Potters of the World." *Muveszet*, Budapest, Hungary, 1979.

"Paul Soldner." *Ceramica* 13, Madrid, Spain (1982): 21–23.

"Paul Soldner and Peter Voulkos: West Coast Ceramics." *Craft Horizons* 26 (July 1966): 26.

Place, Jennifer. "Raku Pottery." *American Artist* 37 (April 1973): 26–31.

Ransom, Connie. "Renaissance Man." *Elan* (November 1990): 58–59.

Rico, Diana. "Artists Are All Fired Up Over Ceramics." *Daily News* (24 July 1984).

Roberts, David. "Paul Soldner: Magic Potter." *Ceramic Review* 109 (January-February, 1988): 34–35.

Rubin, Michael G. "Paul Soldner." *American Ceramics* 1 (Fall 1982): 38–41.

Save, Colette. "Les rencontres d'Aix." *L'atelier des métiers d'art* 65 (1981).

Siegel, Roslyn. "The Potter as Artist: Blurring Distinctions." *New York Times* (21 February 1980).

"The Marer Collection." *Ceramics Monthly* (October 1984): 21–27.

Wagonfeld, Barbara. "Spontaneity Frozen in the Fire." *Craft Range*, 1981.

"West Coast Innovators in Ceramic Media." *Art in America* 64 (July-August 1976): 84–89.

Wortz, Melinda. "Southern California Ceramics in the 1950s." *NCECA: San Jose 82*, Alfred, New York: National Council on Education for the Ceramic Arts, 1982.

E. Books and Catalogues

American Ceramics Now: The 27th Ceramic National Exhibition. Syracuse, N.Y.: Everson Museum of Art, 1987.

Art in Clay, 1950s to 1980s in Southern California:Evolution, Revolution, Continuation. Los Angeles: Municipal Art Gallery, 1984.

Birks, Tony. *Art of the Modern Potter.* New York: Van Nostrand Reinhold, 1976.

Bormann, Gottfried. *Ceramics of the World in 1984.* Düsseldorf: Kunst & Handwerk Verlag, 1984.

———— *Keramik Der Welt.* Düsseldorf: Kunst & Handwerk Verlag, 1984.

Bruning Levine, Nancy. *Hardcore Crafts.* New York: Watson Guptil, 1976.

Byers, Ian. *The Complete Potter: Raku.* London: B. T. Batsford, 1990.

Campbell, Donald. *Using the Potter's Wheel.* New York: Van Nostrand Reinhold, 1977.

Ceramics Review. London: Craftsmen Potter's Association of Great Britain, 1977.

Clark, Garth, and Margie Hughto. *A Century of Ceramics in the United States, 1878-1978.* New York: E.P. Dutton in association with the Everson Museum of Art, Syracuse, N.Y., 1979.

———— *American Ceramics: 1876 to the Present.* New York: Abbeville Press, 1987.

———— *American Potters: The Work of Twenty Modern Masters.* New York: Watson Guptil, 1981.

Conrad, John W. *Contemporary Ceramics.* New York: Prentice-Daniel, 1978.

Counts, Charles. *Pottery Workshop.* New York: Macmillan, 1972.

Dickerson, John. *Raku Handbook.* New York: Van Nostrand Reinhold, 1972.

Donhauser, Paul S. *History of American Ceramics.* Dubuque, Iowa: Kendall/Hunt, 1978.

Drexler Lynn, Martha. *Clay Today: Contemporary Ceramists and Their Work.* Los Angeles: Los Angeles County Museum of Art; San Francisco: Chronicle Books, 1990.

Hall, Julie. *Tradition and Change: The New American Craftsmen.* New York: E.P. Dutton, 1978.

Hirsch, Rick, and Christopher Tyler. *Raku: Techniques for Contemporary Potters.* New York: Watson Guptil, 1975.

Kleinsmith, Gene. *Clay's The Way.* Victor Valley, Ca.: Sono Nis, 1979.

Kriwanek, Franz F. *Keramos.* Dubuque, Iowa: Kendall/Hunt, 1970.

Koeninger, Kay, and Douglas Humble, eds. *Earth and Fire: The Marer Collection of Contemporary Ceramics.* Catalogue of the permanent collection. Claremont, Ca.: Galleries of the Claremont Colleges, 1984.

Lane, Peter. *Studio Ceramics.* Radnor, Pa.: Collins Publishers & Chilton Book Company, 1983.

Levin, Elaine. *The History of American Ceramics: 1607 to the Present.* New York: Harry N. Abrams, 1988.

Lewenstein, Eileen, and Emmanuel Copper. *New Ceramics.* New York: Van Nostrand Reinhold, 1974.

Luise, Billie. *Potworks.* New York: Morrow, 1973.

Lyggard, Finn. *Ceramic Manual.* Denmark: N.p., 1972.

Manhart, Tom, and Marcia Manhart. *The Eloquent Object:The Evolution of American Art in Craft Since 1945.* Tulsa, Ok.: Philbrook Museum; Seattle: University of Washington Press, 1987.

Myers, Bernard S. *Understand the Arts.* New York: Holt, Rinehart & Winston, 1974.

Murray, Rona. *The Art of Earth.* Victoria, British Columbia: N.p., 1979.

Nelson, Glen C. *Ceramics.* Rev. ed. New York: Holt, Rinehart & Winston, 1977.

Nigrosh, Leon. *Low Fire: Other Ways to Work in Clay.* Boston: Davis Publishing, 1980.

Nordness, Lee. *Objects USA.* New York: Viking Press, 1970.

Parks, Dennis. *A Potter's Guide to Raw Glazing and Oil Firing.* New York: Charles Scribner & Sons, 1980.

Pearson, Katherine. *American Crafts: A Source Book for the Home.* New York: Stewart, Tabori & Chang Publishers, 1983.

Perry, Barbara. *American Ceramics: the Collection of the Everson Museum of Art.* Syracuse, N.Y.: Everson Museum of Art and New York: Rizzoli, 1989.

Piepenberg, Robert. *Raku Pottery.* New York: Macmillan, 1971.

Preaud, Tamara, and Serge Gauthier. *Ceramics of the 20th Century.* New York: Rizzoli, 1982.

Raku: Transforming the Tradition. Kansas City: Kansas City Contemporary Art Center in association with the National Council on Education for the Ceramic Arts, 1989.

Rhodes, Daniel. *Kiln Building.* Philadelphia: Chilton, 1973.

———— *Stoneware and Porcelain: The Art of High Fired Pottery.* Philadelphia: Chilton, 1959.

Slivka, Rose, Aileen Webb, and Marge Patch. *Crafts of the Modern World.* New York: Horizon Press, 1968.

Smith, Paul J., and Edward Lucie-Smith. *Craft Today: Poetry of the Physical.* New York: American Craft Museum and Weidenfeld & Nicolson, 1986.

Soldner, Paul, and Jim Melchert. *The Fred and Mary Marer Collection: 30th Annual Ceramics Exhibition.* Claremont, Ca.: Lang Art Gallery, Scripps College, 1984.

Trevor, Harry. *Pottery.* New York: Watson Guptil, 1975.

Troy, Jack. *Salt Glazed Ceramics.* New York: Watson Guptil, 1977.

Wechsler, Susan. *Low Fire Ceramics: A New Direction in American Clay.* New York: Watson Guptil, 1981.

Williams, Gerry, Peter Sabin, and Sarah Bodine. *Studio Potter Book.* New York: Van Nostrand Reinhold, 1978.

Woody, Elsbeth. *Handbuilding Ceramic Forms.* New York: Farrar, Straus & Giroux, 1978.